TIGER SEEN ON
SHAFTESBURY AVENUE

THE NATIONAL GALLERY'S GRAND TOUR

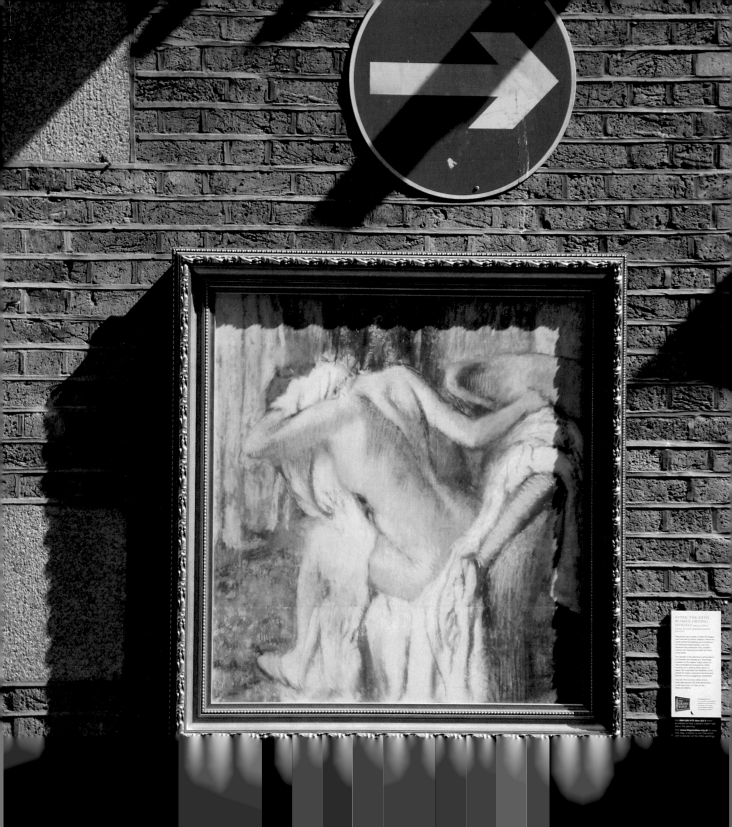

THE NATIONAL GALLERY houses a spectacular collection of paintings in trust for the nation, but not everyone knows about the treasures it holds. This is why Hewlett-Packard was delighted to get involved with the Grand Tour, promoting access for everyone to the collection.

The project generated overwhelming levels of interest, including many comments on the high quality of the reproductions. Some passers-by, initially puzzled by the paintings, were seen reaching out to touch their surface to discover whether they were 'real'. Surely the Gallery had not been so careless as to misplace a Rembrandt in Covent Garden!

This illusion, central to the success of the Grand Tour, was made possible by Hewlett-Packard's imaging and printing capabilities. Using the new DesignJet 10000s, capable of handling super-wide formats at exceptional quality, it was possible to reproduce mirror images of the National Gallery's paintings.

But that was not all. In addition to ensuring accuracy of detail and colour, the paintings were printed on a new, hardwearing material to guarantee that they were waterproof and graffiti-proof, ready to withstand the rigours of London life.

Hewlett-Packard and the National Gallery have been partners since 1998. Ranging from the study of precise brushwork, to colour-matching for art restoration, to the digitisation of the permanent collection, the collaboration has applied technology to preserve and promote access to the Gallery's Collection. The Grand Tour provided a new challenge, and an exciting journey, that Hewlett-Packard was delighted to share with the National Gallery.

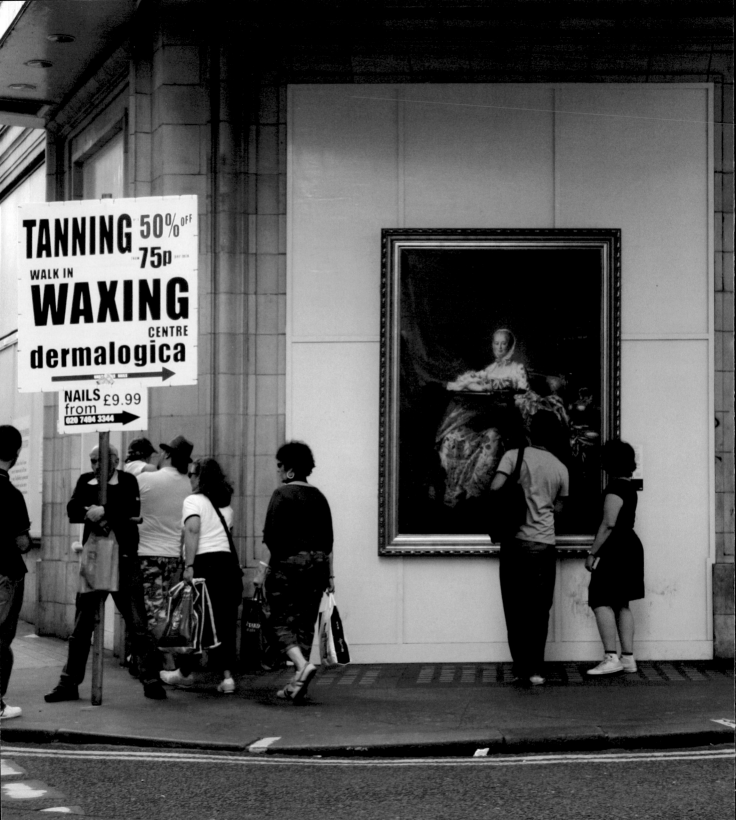

THE GRAND TOUR was a startlingly unusual project, a billboard campaign with nothing to advertise but the genius of the Old Masters. The results varied from intriguing to outright disconcerting, although the idea was simplicity itself. Forty-four great paintings from the National Gallery were reproduced to exact scale, and beguiling fidelity to the colours of the originals, with the help of new printing technology developed by Hewlett-Packard. Handsomely framed, these plausible lookalikes were then hung outdoors, at eye level, on selected streets in London's West End. So it was that Soho and Seven Dials became the setting for an impromptu exhibition of images by the likes of Holbein and Rubens, Titian and Turner.

Thought-provoking incongruities abounded. At one end of Kingly Street, Seurat's famous *Bathers* suddenly materialized (p. 17). A nineteenth-century painting of would-be escapees from the bustle of metropolitan Paris had itself been thrust into the crush of modern-day London. Not far away, lurking on the corner of Fouberts Place, was Quinten Massys's *Grotesque Old Woman* (p. 24). She is a bit of a character, twisted by life into a gnarled human tree-trunk – not hard to imagine her asking passers-by if they can spare a bit of loose change.

The pictures could be equally effective when looking completely out of place. Velázquez's *Philip IV of Spain*, with his sad-eyed aloofness, seemed all the more disdainful of the people at large when staring down from a wall outside Caffè Nero (p. 51). Holbein's demurely sexy portrait of *Christina of Denmark* was hung in the middle of Broadwick Street (p. 94). Her withdrawn, reserved quality is actually enhanced when the sight of her is intermittently interrupted by buzzing mopeds, or accompanied by the sound of people shouting over the traffic into their mobile phones.

The original Grand Tour was dreamed up by the aristocrats of Georgian England. Travelling to foreign climes, to France and above all Italy, a young milord was to broaden his horizons by encountering the great works of European art and architecture at first hand. The National Gallery's Grand Tour – a tongue-in-cheek title if ever there was one – cannily reversed that by having art travel out to the general public. It invited people to linger on each individual painting, to consider its meaning, its power, its subtlety. That kind of intimate, considered contemplation of single works of art is at the heart of the experience that the National Gallery offers. At base, the aim of the Grand Tour was to remind the inhabitants of London that they have, right on their doorsteps, one of the world's great treasure-houses of European painting. And unlike most other such treasure houses – the Louvre in Paris, or the Prado in Madrid – it is free of charge.

To complain, as some did, that the Grand Tour was a gimmick, seems curiously beside the point. What set it apart was its naked success. Not only did it get a lot of people who might never normally consider going to the National Gallery to give a bit of thought to some of the great images of Western art. It also got a lot of people who might never normally consider going to the National Gallery actually to do so for the first time.

ANDREW GRAHAM-DIXON
Art historian, writer and broadcaster

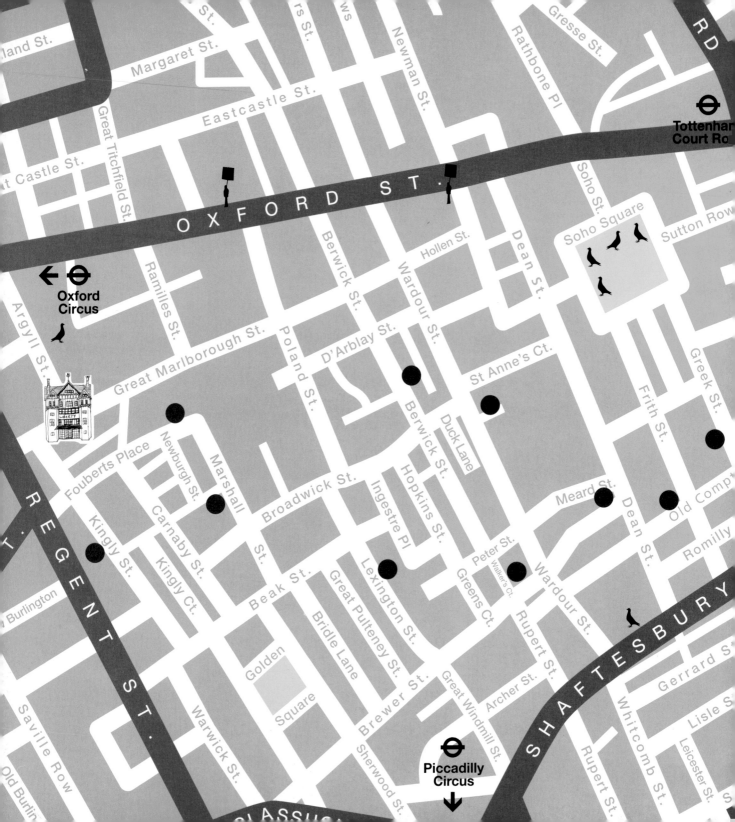

RUBENS
TITIAN
SEURAT
CARAVAGGIO
BRONZINO
MASSYS
HOLBEIN
GAINSBOROUGH
VAN GOGH
WRIGHT OF DERBY

HOME TO INTERNATIONAL FILM COMPANIES, crowded restaurants and hip cocktails bars, today's Soho is a far cry from its origins as a royal hunting ground.

Or is it? It could be said that it's been hunters' territory ever since – from those stalking red-light action within its seedy underbelly, to the media darlings scouring its various coffee houses in search of the perfect macchiato. Indeed, even the area's name comes from an old hunting cry, 'So ho!'

Penned in by the busy thoroughfares of Oxford Street, Regent Street, Charing Cross Road and Shaftesbury Avenue, this tight network of narrow streets is a workplace for some and playground for many. It's an area best defined by its cosmopolitan diversity, where Korean barbeque joints and Japanese karaoke dens rub shoulders with traditional French patisseries and Italian barbers.

Soho's enduring popularity is best witnessed at its two main squares (Golden and Soho), where, at the first hint of sunshine, the hoards descend to lunch alfresco and bare more skin than the temperatures should allow. Or, inside one of its numerous pubs, where every seat is taken soon after 5pm and many patrons spend the night jostling for space on the pavements outside. It's scenes like these that place Soho at the social heart of London.

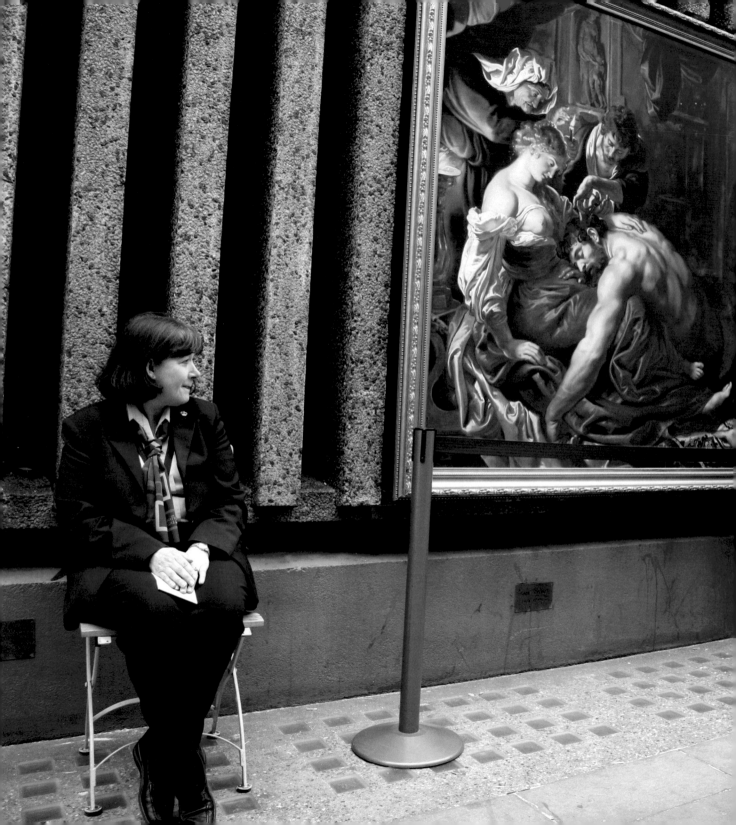

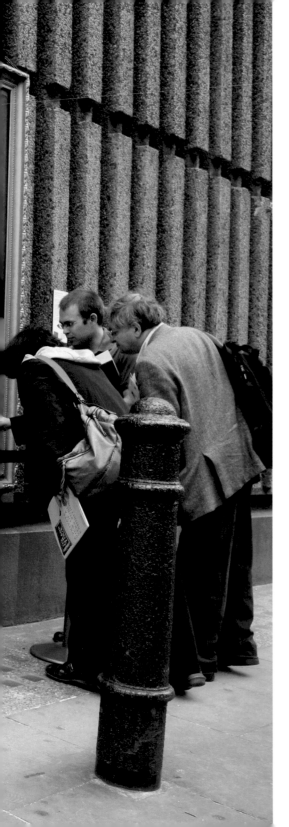

Samson and Delilah, about 1609–10

Rubens (1577–1640)
Photograph: **MATT STUART**

This shows the end of the first superhero,
the Arnold Schwarzenegger of his time.
There is a wonderful sense of this huge,
powerful man slumped on Delilah's lap.

David Jaffé, Curator, The National Gallery

The Grand Tour was launched by the Director of the National Gallery,
the Lord Mayor of Westminster and Andrew Graham-Dixon (pictured left).

 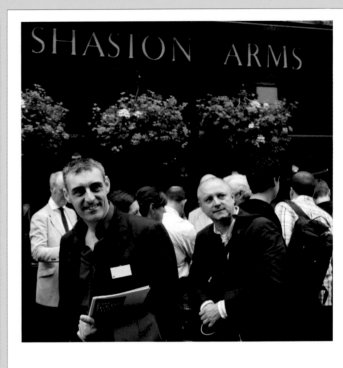

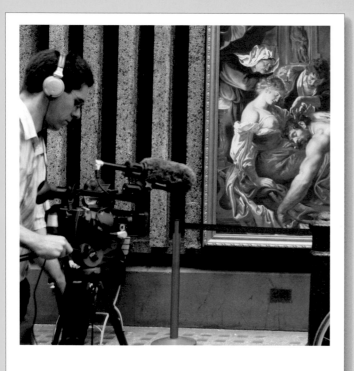

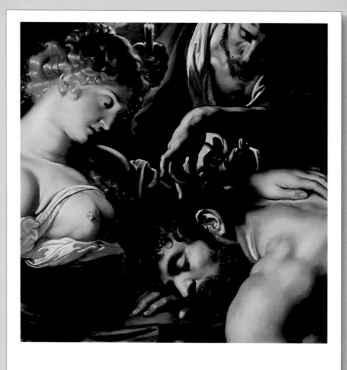

The painting on our wall was very nice viewing for the odd couple of guys who used to come in and look over there and see Delilah's boobs flashed all over the place. You know what I mean?

MANAGER, THE SHASTON ARMS, SITE OF *SAMSON AND DELILAH*

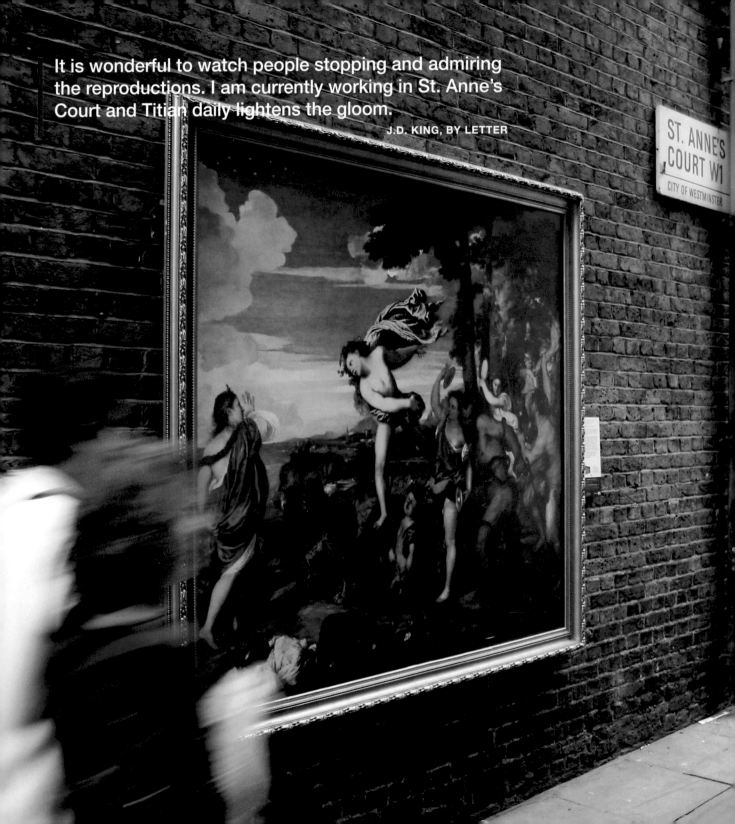

It is wonderful to watch people stopping and admiring the reproductions. I am currently working in St. Anne's Court and Titian daily lightens the gloom.

J.D. KING, BY LETTER

ST. ANNE'S COURT W1
CITY OF WESTMINSTER

Bacchus and Ariadne, 1520–3

Titian (active about 1506; died 1576)

Soho is infinite and mazelike, a
meeting place of shifting landmarks
and furtive delights. It seems fitting
to me that the National Gallery has
secreted away these surprises here.

ALLYSON SHAW, BLOG

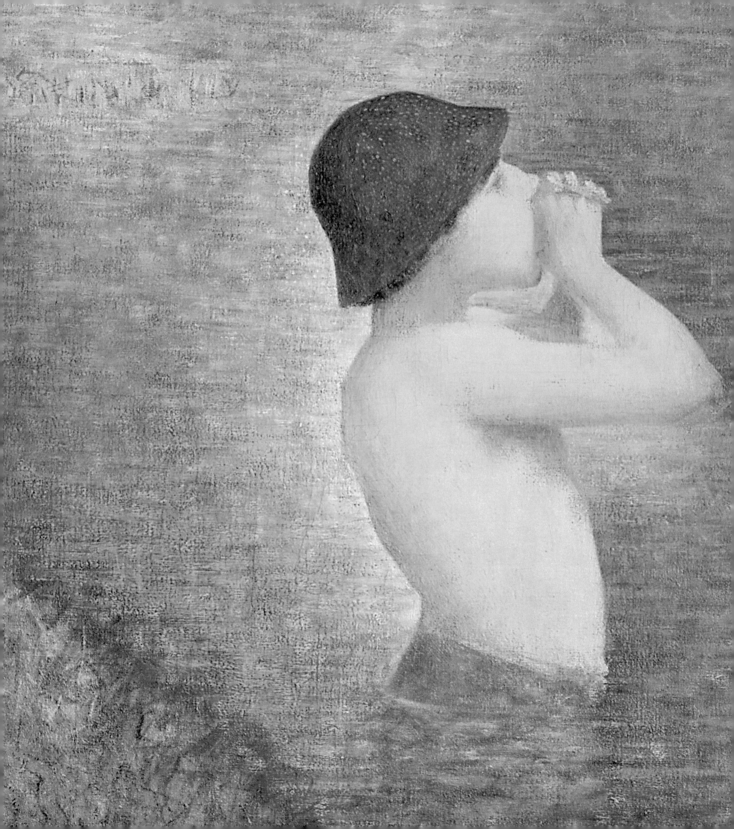

Bathers at Asnières, 1884

Seurat (1859–1891)

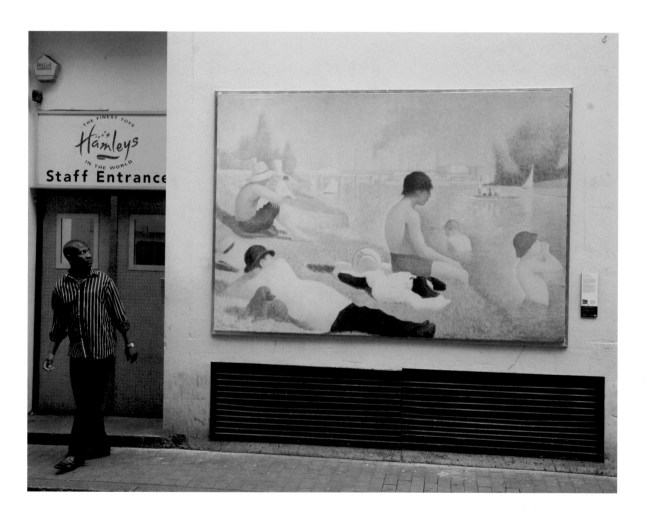

It's got people talking, and that's great.
It made me stop.

PASSER-BY

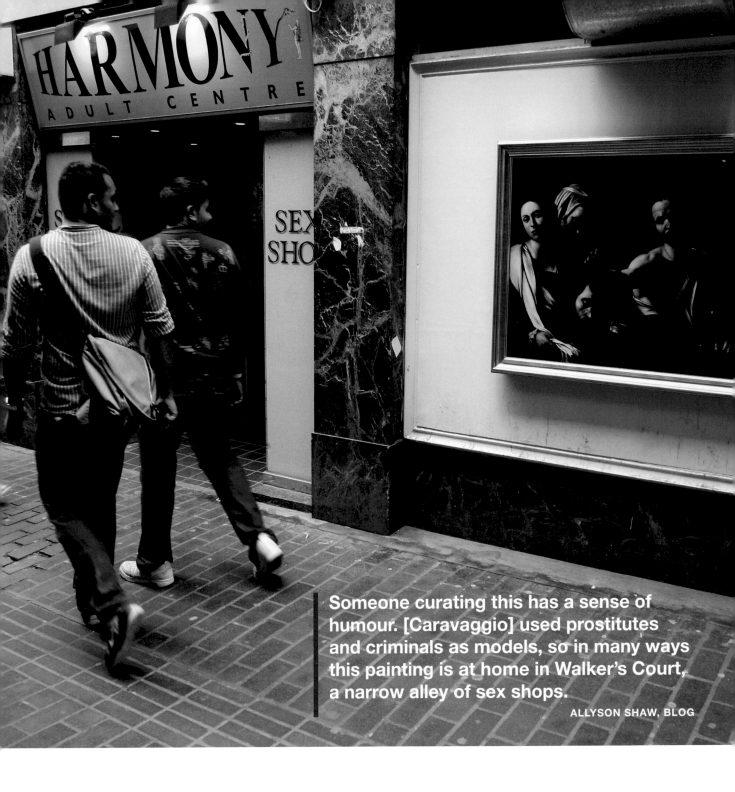

Someone curating this has a sense of humour. [Caravaggio] used prostitutes and criminals as models, so in many ways this painting is at home in Walker's Court, a narrow alley of sex shops.

ALLYSON SHAW, BLOG

Salome receives the Head of Saint John the Baptist, 1607–10

Caravaggio (1571–1610)
Photograph: **MATT STUART**

Having *Salome* on Walker's Court was a bit strange because it's a religious painting and you're in the middle of Soho here ... But there were prostitutes in the Bible – it's the oldest profession in the world!

I prefer a landscape – nice fields and a cottage – but this is alright: you can tell it's art – there's a bit of skill there. It wasn't like Jackson Pollock or anyone who just flicks paint. What's all that about? That's not art – I could do that couldn't I? Anyone could do that!

SHOP WORKER FROM HARMONY

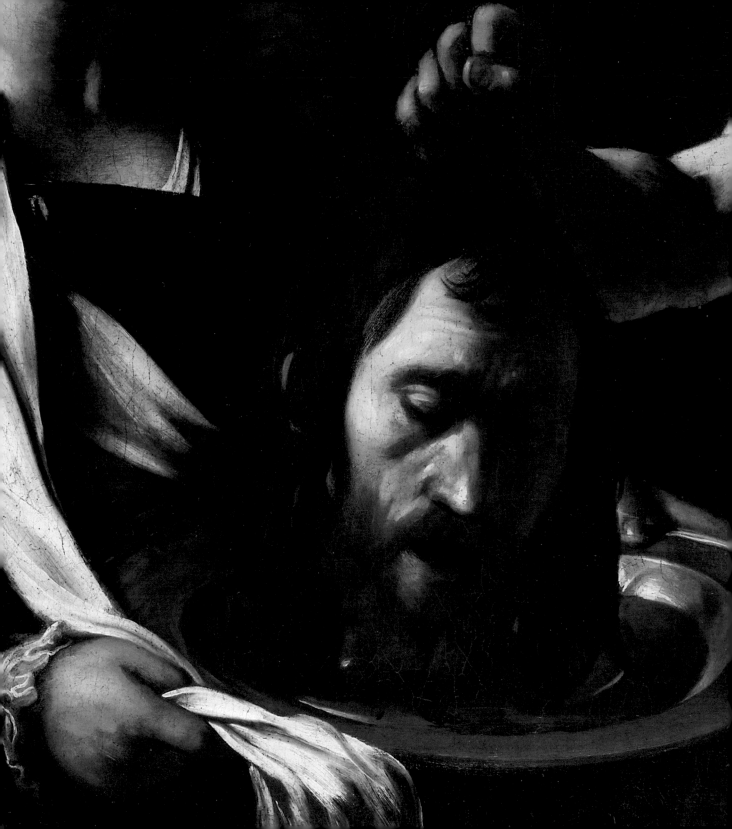

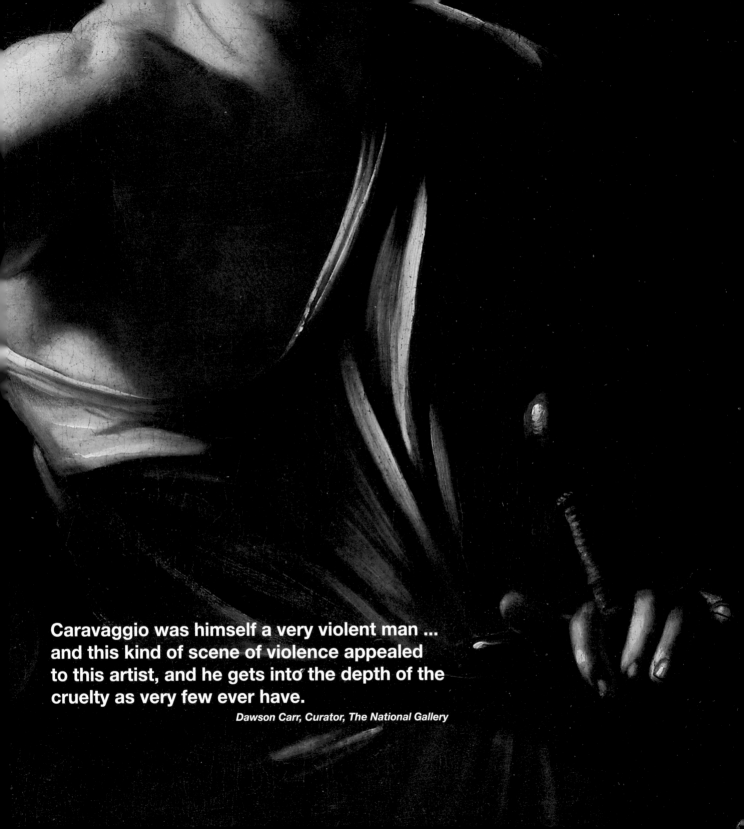

Caravaggio was himself a very violent man ...
and this kind of scene of violence appealed
to this artist, and he gets into the depth of the
cruelty as very few ever have.

Dawson Carr, Curator, The National Gallery

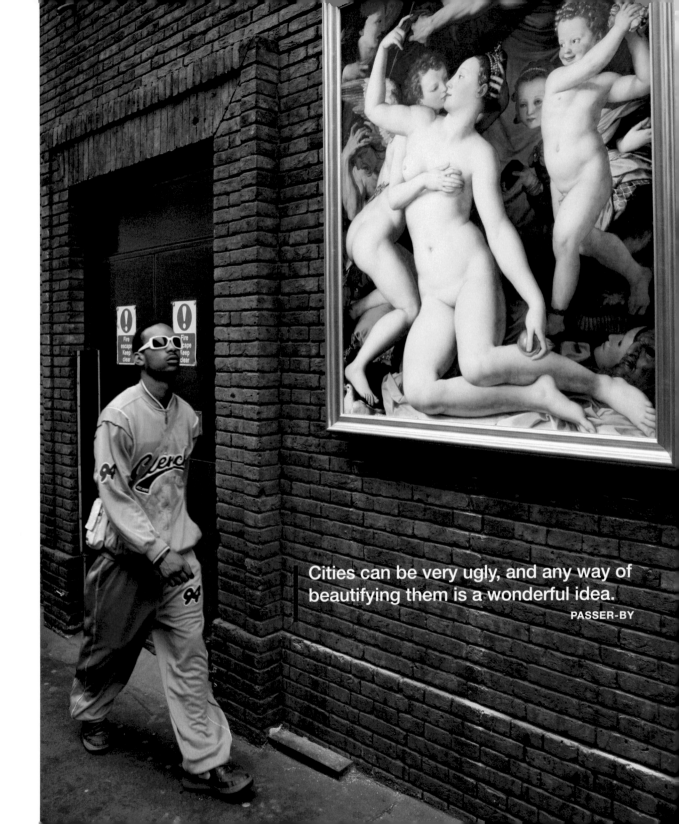

Cities can be very ugly, and any way of beautifying them is a wonderful idea.

PASSER-BY

An Allegory with Venus and Cupid, probably 1540–50

Bronzino (1503–1572)

Photograph: **MATT STUART**

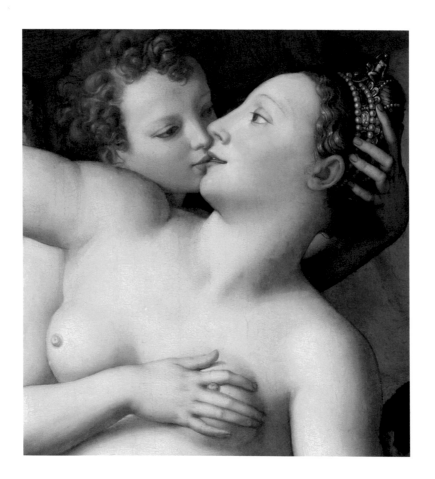

Sex. That's what this picture is about. But
I don't think you need to be an art historian
to understand that.

Colin Wiggins, Education Department,
The National Gallery

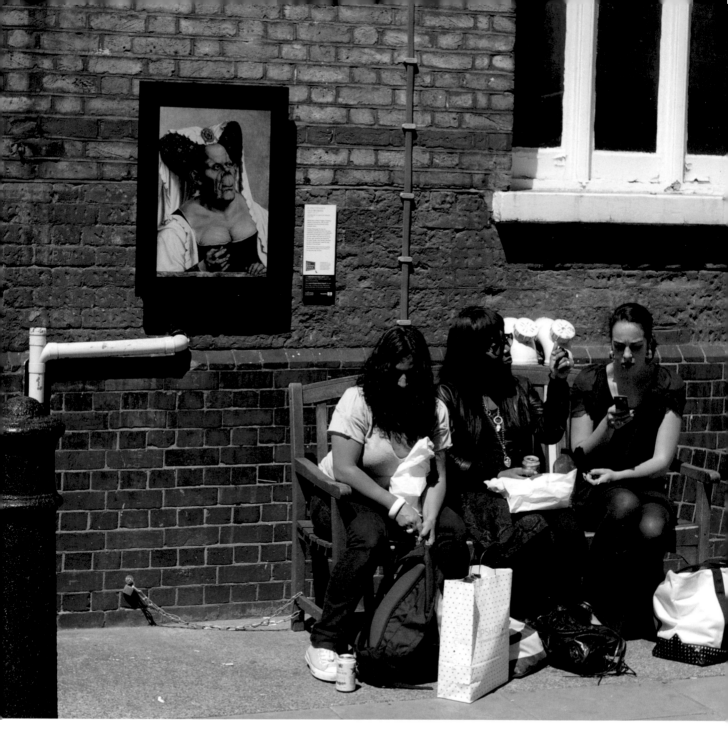

A Grotesque Old Woman, about 1525–30

Attributed to Massys (1465–1530)
Photograph: **MATTHEW HYDE**

The sixteenth-century *Grotesque Old Woman*, said to have inspired Tenniel's illustration of the Ugly Duchess in *Alice in Wonderland*, looks quite at home in Fouberts Place, a district famous then and now for its eccentrics.

MAEV KENNEDY, *THE GUARDIAN*

This extraordinary painting is known as *The Grotesque Old Woman*, and I think it's lucky that we have the title because many people are confused about whether we are in fact looking at a woman at all.

Al Johnson, Lecturer, The National Gallery

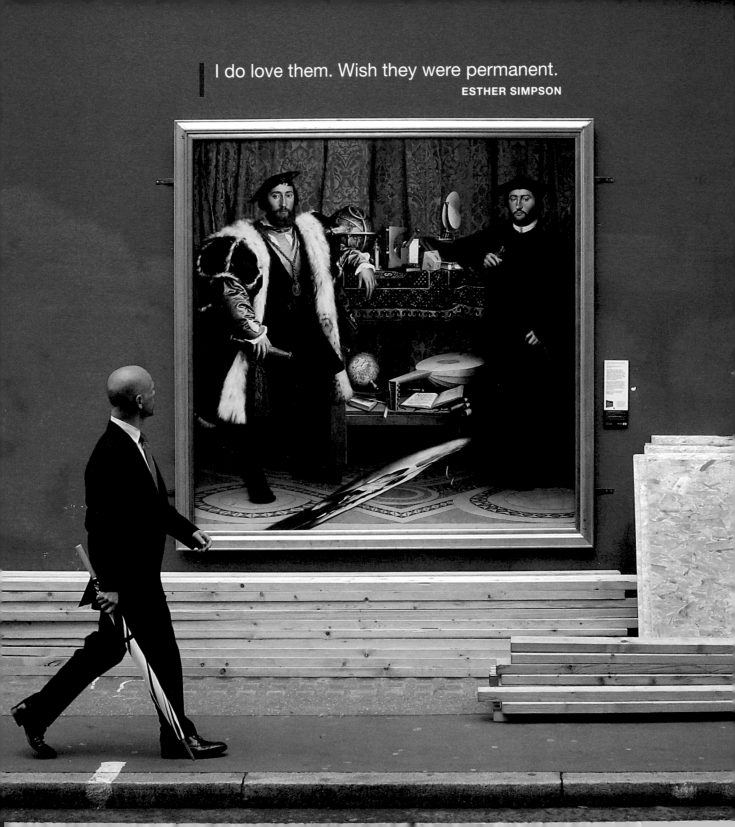

The Ambassadors, 1533

Holbein (1497/8–1543)
Photograph: **ESTHER SIMPSON** (opposite)

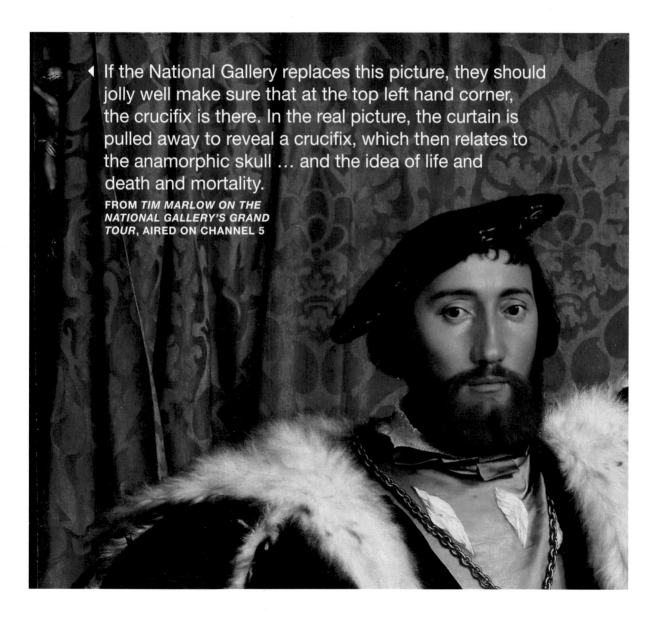

◀ If the National Gallery replaces this picture, they should jolly well make sure that at the top left hand corner, the crucifix is there. In the real picture, the curtain is pulled away to reveal a crucifix, which then relates to the anamorphic skull ... and the idea of life and death and mortality.

FROM *TIM MARLOW ON THE NATIONAL GALLERY'S GRAND TOUR*, AIRED ON CHANNEL 5

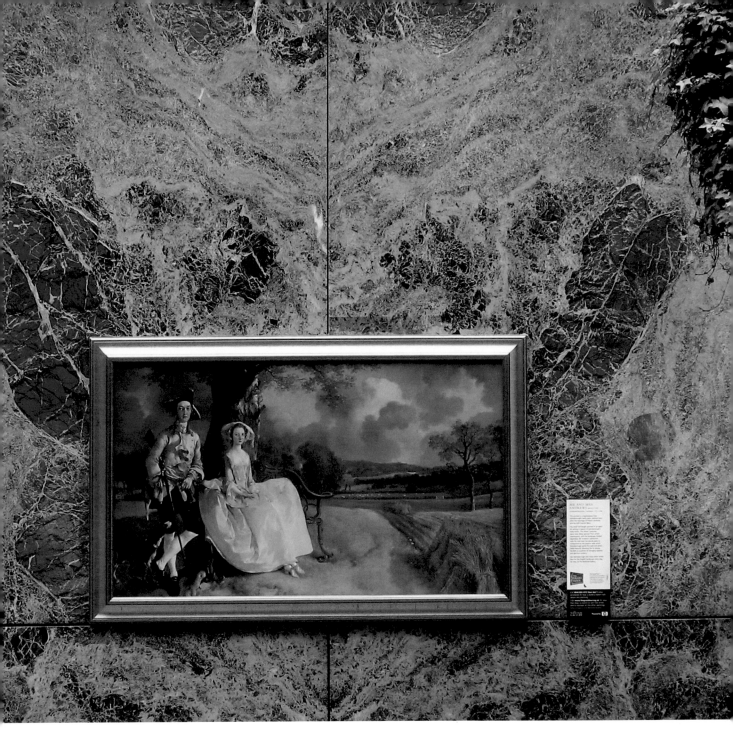

Mr and Mrs Andrews, about 1750

Gainsborough (1727–1788)
Photograph: **ESTHER SIMPSON**

It has brightened up my day walking through all my local haunts seeing a little bit of our National Gallery.

CRAIG SUGDEN, GALLERY VISITOR

Everywhere you went there would always be another one pop up and you'd always go 'oh! I hadn't seen that one yet'.

MANAGER, THE SHASTON ARMS, GANTON STREET

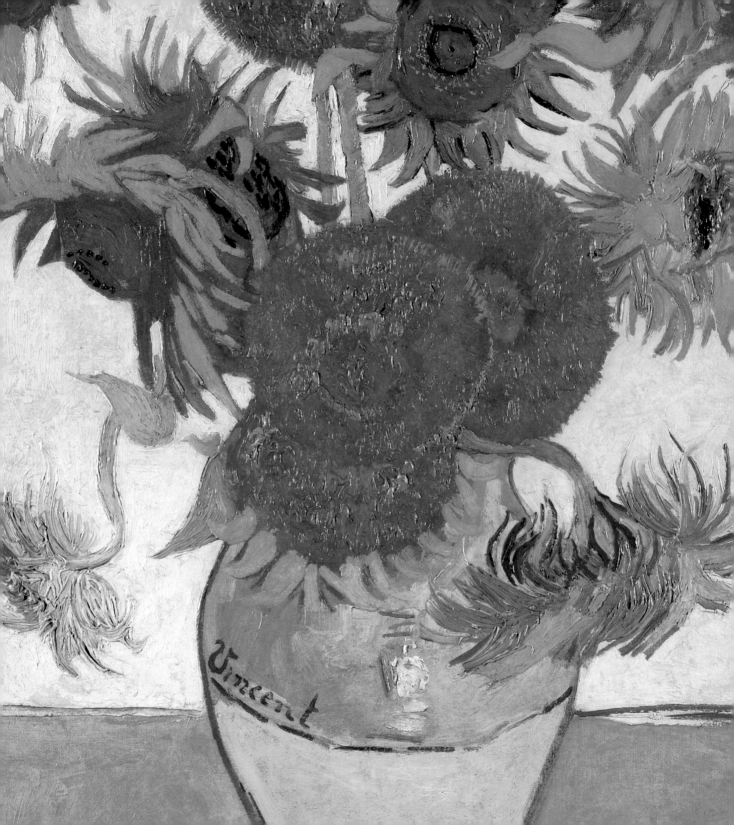

Sunflowers, 1888

Van Gogh (1853–1890)

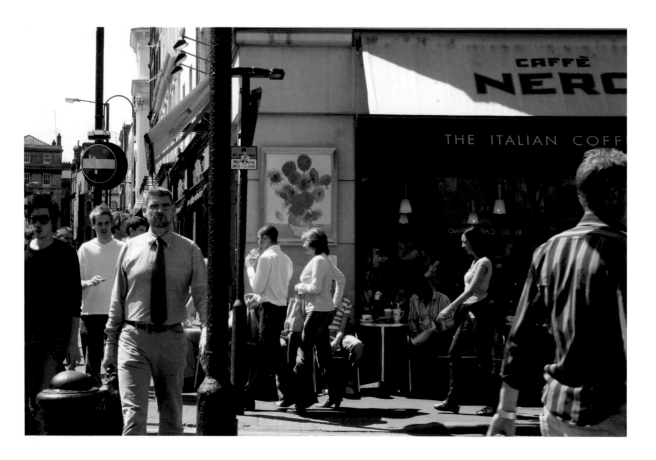

There are so many beautiful things in
the National Gallery, but I bet most people
have never even been there.

PASSER-BY

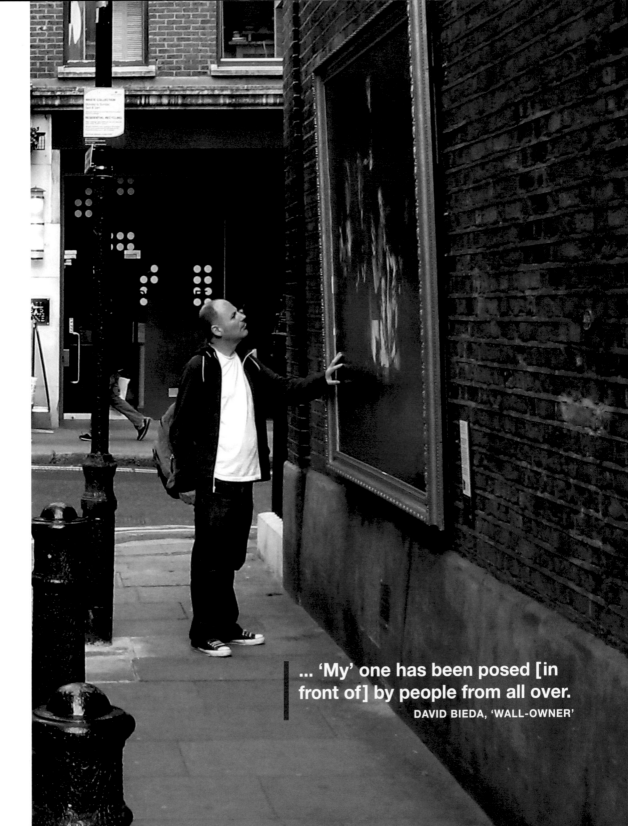

... 'My' one has been posed [in front of] by people from all over.

DAVID BIEDA, 'WALL-OWNER'

An Experiment on a Bird in the Air Pump, 1768

Wright of Derby (1734–1797)
Photograph: **NOEL TREACY**

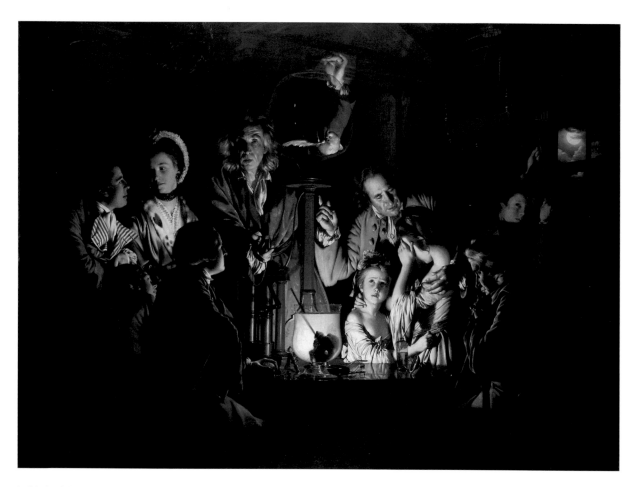

I think this might be one of the first instances of this idea of a scientist playing God – an issue that is alive and kicking in the twenty-first century.

*Colin Wiggins, Education Department,
The National Gallery*

This people's peep show proves we still have vision

BY RACHEL COOKE
Observer
17 July 2007

My admiration for David Hockney is pretty full-on: if Bridlington were not so far away I could very easily turn into his stalker. I regard him as our greatest living artist and greet his every pronouncement with a loud clap of my hands. The flatter the vowels, the better. So when, last week, he indulged in what for him was a fairly low-level rant about how he fears that we are entering a post-visual age, I was all set to agree. You're absolutely right, David, I thought. We do spend far too much time listening to our iPods and not enough gazing out of the window – and, yes, the result of this is that people are visually illiterate, unable either to draw or to dress themselves ('it produces a lot of badly dressed people', he said, with a twang of his polka-dot braces).

But I was just getting carried away, as usual. This time Hockney has slipped up. On the matter of drawing, he is spot on. I know enough about what goes on in art schools to be sure of that. But I'm not convinced that most people – or at least those who live in cities – are visually illiterate. It's more that they have learned to edit all the

visual junk: the orange bollards; the men in fluorescent jackets digging pointless holes; the billboards; the heaps of freesheets; the plastic bags oozing stinking rubbish.

The National Gallery's experimental Grand Tour illustrates this selective blindness perfectly. The Grand Tour is a new project in which 44 high quality photographic reproductions of some of the gallery's most famous paintings have been scattered throughout Soho and Covent

The images, hunkered down in gloomy alleys, or loitering at the doors of cafés and sex shops, manage to make their presence felt in spite of the competition.

Garden. The paintings are framed, and come with notes as they would in the gallery, but now they are out in the world, to be discovered by accident. When I read about this I thought: who, as they scurry from Pret a Manger to Ryman's, is honestly going to notice that over there, just by the door of Caffè Nero, is Diego Velázquez's portrait of Philip IV of Spain? But then I took a walk through town my-

self, and suddenly the whole thing made sense. The images, hunkered down in gloomy alleys, or loitering at the doors of cafés and sex shops, manage to make their presence felt in spite of the competition. A great painting is still a great painting, even when it's released from the pristine sanctity of a gallery – or perhaps especially when it is. Anyone who has ever visited a gallery is familiar with the exhausting syndrome of gallery vision, when you look and look but still don't see. But when you're out in the streets, a work like Joseph Wright's incredibly strange *An Experiment on a Bird in the Air Pump* – a cockatoo is about to suffocate in a glass dome – shouts at you through the urban fuzz. It's in colour; everything else is in black and white. Wright's painting, which I love, is in Meard Street, in Soho, which smells of pee. Last week, as I passed by, I heard a guy in aviator sunglasses say under his breath no fewer than three times: 'What's this all about?' Exactly the right question.

The Grand Tour is intended to remind us that these paintings can be seen free any day of the week just up the road (only 28 per cent of the National Gallery's visitors are Londoners; when the Gallery staged its recent Manet to Picasso show, many visitors were amazed to be told that all the paintings belonged to its permanent collection). But so startling is the effect – the reproductions really are good, the locations witty and surprising – that I think it works as an exhibition in its own right.

It's also a perfect exercise, in branding terms, in simplicity. Two weeks on, and we are still worked up about the awful 2012 Olympics logo, the bill for which is £400,000. The National Gallery's extended advertisement cost it next to nothing. The

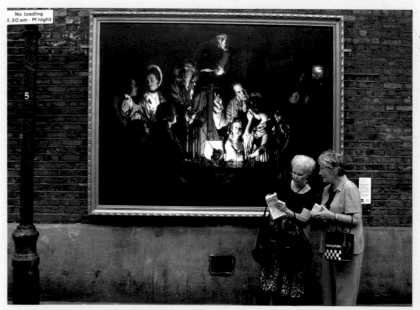

Out in the streets, people are removing their little white headphones and stopping in their tracks.

reproductions were printed by Hewlett-Packard, one of its sponsors, and will be recycled when the whole thing is over (they will be sent to schools and hospitals). The owners of the 44 walls on which the images have been stuck all donated their sites. This bare bones value appeals to the ascetic in me, though the Grand Tour would be worth it even if the bill were rather bigger. It's so much more than an ad; it's a public service, and a treat. I just wish they would take it to other cities; the train companies could sponsor it in return for a mention of the price of an Apex ticket.

So Hockney is wrong to worry that, outside of spaces devoted to art, people's eyes are no longer capable of giving them pleasure. We might be entirely oblivious of the identikit noodle bar that opened on the corner three months ago – and that can only be a good thing – but Stubbs's *Whistlejacket*, dancing on a wall in Seven Dials, is quite a different matter. Out in the streets, people are removing their little white headphones and stopping in their tracks.

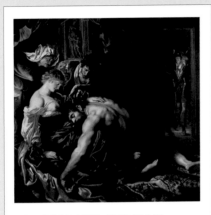

SAMSON AND DELILAH, ABOUT 1609–10

PETER PAUL RUBENS (1577–1640)

Like a still from a film, Rubens's painting of Delilah's betrayal of Samson freeze-frames all the drama of a moment in time.

It's a retelling of the powerful story from the Old Testament (Judges 16: 17–20), where the mighty Jewish hero falls for the wanton charms of a prostitute, and rashly reveals that the secret of his strength lies in his flowing, uncut locks. Having exhausted him in a night of passion, she calls in the barber, and hands him over emasculated to his sworn enemies, the Philistines.

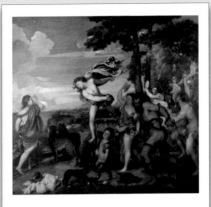

BACCHUS AND ARIADNE, 1520–3

TITIAN (ACTIVE ABOUT 1506; DIED 1576)

This is the moment Bacchus, god of wine, emerging from a night out with his rowdy crew, sets eyes on Ariadne and falls in love. The pair appear to pause on a single heartbeat as they catch sight of each other.

Startled Ariadne has just been abandoned by her former lover, Theseus, after helping him defeat the Minotaur. You can see his ship sailing off in the distance. Bacchus raises her up to heaven and turns her into a constellation, represented by the stars above her head. Titian unfolds all the drama and mixed emotions of the scene using his trademark blazing colour and consummate dexterity.

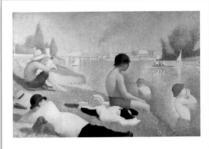

BATHERS AT ASNIÈRES, 1884

GEORGES SEURAT (1859–1891)

When Seurat presented his mammoth canvas to the influential Paris Salon of 1884, it was thrown out for being too radical. Why? Because it shows working-class men on a majestic scale usually reserved for gods and noblemen.

Bathers is set on the River Seine in north-west Paris. Seurat had yet to perfect his pointillist technique, made up of lots of small dots, like a television picture. But he added some later, notably to the boy's hat.

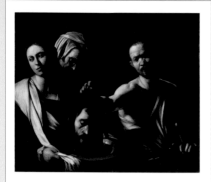

SALOME RECEIVES THE HEAD OF SAINT JOHN THE BAPTIST, 1607–10

MICHELANGELO MERISI DA CARAVAGGIO (1571–1610)

This was painted in Naples not long before Caravaggio's death. It depicts the gruesome New Testament story of Salome (Mark 4: 21-8), who danced so well for King Herod that he swore he would give her anything.

Encouraged by her vengeful mother, she asked for the head of John the Baptist on a plate. The pathos and human tragedy of the tale are delivered with exceptional economy and brutal raw power.

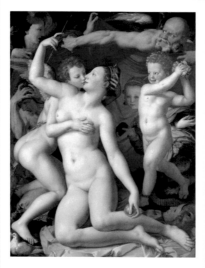

AN ALLEGORY WITH VENUS AND CUPID, PROBABLY 1540–50

BRONZINO (1503–1572)

Bronzino was the ultra-fashionable court painter to the Medici family, absolute rulers of Florence. Duke Cosimo was responsible for commissioning this salacious image as a present for the King of France, Francis I, a man with a notorious lust for flesh.

Packed with riddles and symbolism, the complex allegory would have given the king plenty of excuse to ponder the painting, while ogling the sensual bodies of the cavorting Venus and Cupid.

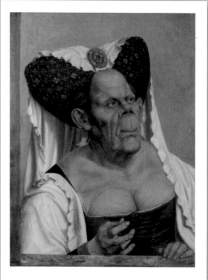

A GROTESQUE OLD WOMAN, ABOUT 1525–30

ATTRIBUTED TO QUINTEN MASSYS (1465–1530)

Massys was a cultural magpie. A leading painter in Antwerp by 1510, he drew inspiration from local Flemish artists, amongst others.

Perhaps Massys got the idea for *A Grotesque Old Woman* from the many crude faces Leonardo da Vinci drew in his notebooks. The withered old lady is dressed in an inappropriately low-cut gown, and the painting is thought to be a satire on vain old women who dress too young for their age. Someone was inspired by her looks though. John Tenniel, illustrator of *Alice in Wonderland* published in 1865, based his Ugly Duchess on her.

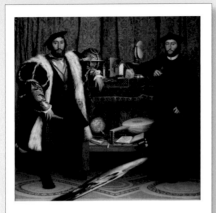

THE AMBASSADORS, 1533

HANS HOLBEIN THE YOUNGER
(1497/8–1543)

This is a huge, full-length portrait of a couple of young men who had it all. In the pink shirt is Jean de Dinteville, French Ambassador to England in 1533. The more sober one is his friend, Georges de Selve, the Bishop of Lavaur. They are surrounded by symbolic objects reflecting their education and interests.

Even as he's immortalising them in art, Holbein reminds us we'll all die in the end. If you try standing to the right of the painting and bending over to look at the curious oblong disk between the ambassadors, you should see a human skull. This signifies the brevity of life.

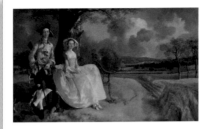

MR AND MRS ANDREWS, ABOUT 1750

THOMAS GAINSBOROUGH
(1727–1788)

This portrait is a masterpiece from Gainsborough's early years, painted soon after the marriage of Robert Andrews and his wife Frances Mary.

The small full-length portrait in an open-air setting is typical of Gainsborough's early works. The sitters' costumes were most likely painted from dressed-up artists' mannequins, with the landscape studied separately. Mr Andrews' satisfaction with his well-kept farmlands is complemented by the passion with which Gainsborough paints the gold and green fields, allowing him to display his skills as a painter of changing weather and glorious scenery.

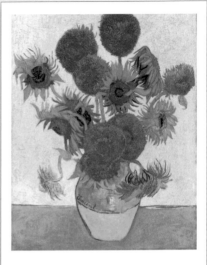

SUNFLOWERS, 1888

VINCENT VAN GOGH
(1853–1890)

Van Gogh painted a series of sunflowers anticipating the arrival of his friend – the poet-artist Gauguin – to his house in Arles, France in 1888.

The painting is strikingly yellow, using newly invented pigments that made vibrant new colours possible. For van Gogh, yellow symbolised happiness. This is ironic, because it was the heated rows he had while working with Gauguin that finally tipped the troubled artist into despair and madness.

Sunflowers is the best-selling postcard and poster at the National Gallery.

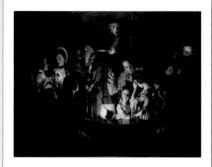

AN EXPERIMENT ON A BIRD IN THE AIR PUMP, 1768

JOSEPH WRIGHT OF DERBY
(1734–1797)

Joseph Wright came from Derby, a town that was at the centre of the Industrial Revolution, and his work reflects the progress it brought about.

The painting shows a lecturer conducting a dramatic experiment as family entertainment. A rare white cockatoo is held in a flask from which the air is being removed. Unless it gets oxygen soon, it will die. The reactions around the candlelit table are minutely observed – from morbid fascination, to distress, to the distracted lovers on the left who pay no attention. The boy on the right, confident the valuable bird will be saved, starts to lower its cage.

MADAME DE POMPADOUR AT HER TAMBOUR FRAME, (1763–4)

FRANÇOIS-HUBERT DROUAIS
(1727–1775)

Drouais was the fashionable portraitist to the French court of Louis XV, and Madame de Pompadour the King's mistress. Drouais painted her head first, presumably from life, and then added it to the rest of the picture, which was on a different canvas. The painting was completed the following year, after Madame de Pompadour's death at the age of just 43.

Highly educated, she's shown here embroidering on a worktable or 'tambour', surrounded by emblems of her interests – books, a mandolin, an artist's folio and her beloved pet dog.

CHRISTINA OF DENMARK, DUCHESS OF MILAN, 1538

HANS HOLBEIN THE YOUNGER
(1497/8–1543)

Holbein's picture of the demure widow Christina of Denmark was painted for the benefit of Henry VIII of England, who was looking for a fourth wife after Jane Seymour.

This portrait was painted when Christina was just 16, and a renowned beauty. The king was said to have fallen madly in love with her on the strength of the painting, an infatuation shared with generations of viewers. Perhaps fortunately for her, the marriage never took place, and she lived into old age.

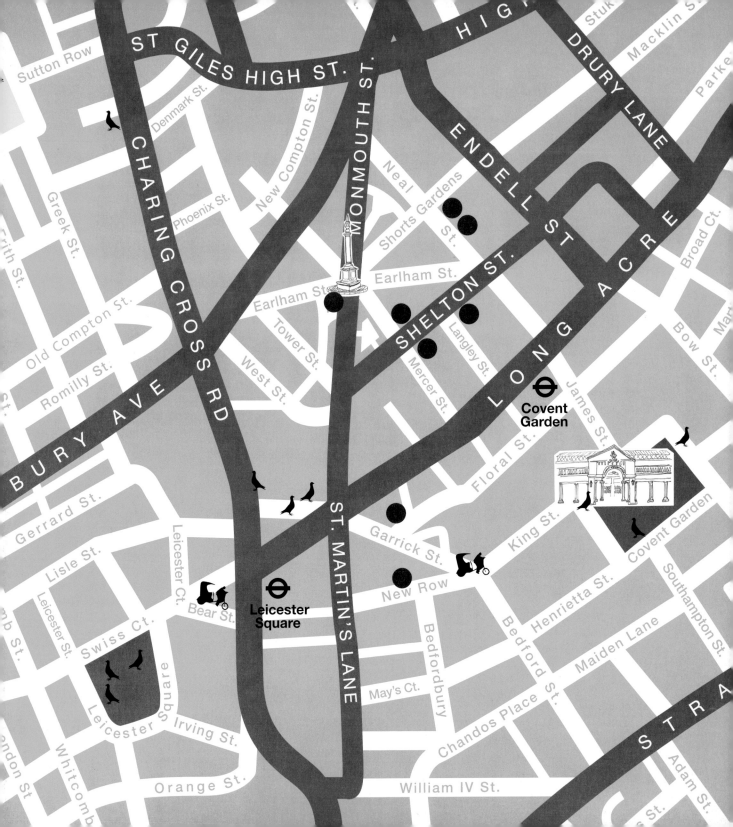

COVENT GARDEN

RENOIR
CLAUDE
VELAZQUEZ
REMBRANDT
MONET
STUBBS
VERMEER
POUSSIN

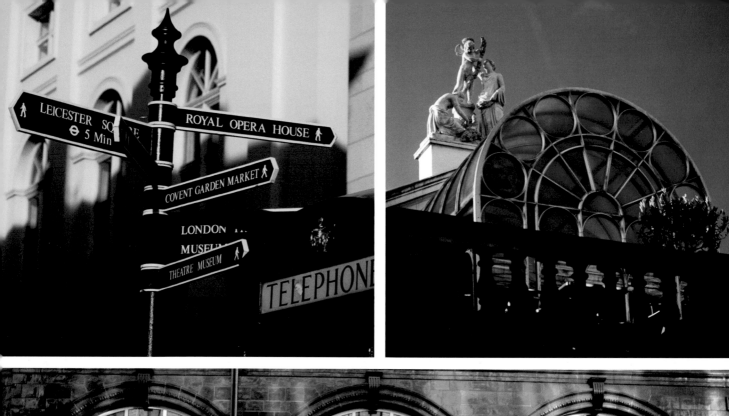

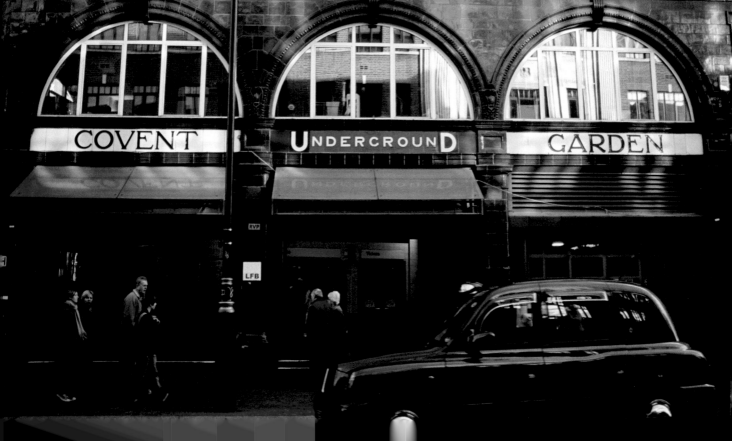

IF ASKED TO CHOOSE A WELL-KNOWN FACE to represent Covent Garden, there would be no shortage of contenders. Eliza Dolittle selling her flowers outside the market perhaps? Or one of the literary greats – Dickens, Pepys or Johnson – that once congregated in the local taverns to put the world to rights? There could even be a case for picking one of the current crop of bizarrely painted street performers, now as much of a feature here as a Beefeater at the Tower of London or the Queen's guards at Buckingham Palace.

Covent Garden is photo opportunity heaven for the throngs of tourists that congregate here on a daily basis to find musicians, magicians and human statues all competing for their attention. Meanwhile, Londoners put on their own performance – expertly demonstrating how they have mastered the art of the no-eye-contact, keep-moving tactic, as they go about their work or embark on various shopping missions.

However, culture is the area's true lifeblood, with a thriving theatre district and a world-class opera house. And, whether you reserve a seat in the stalls, or simply take to the streets, Covent Garden will always treat you to a lively performance.

Hanging *The Skiff* at Café Eterno

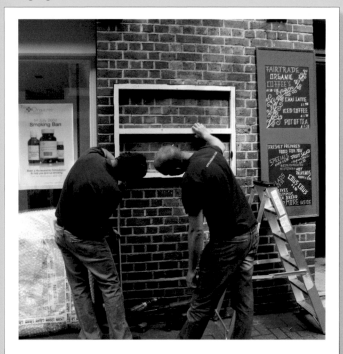 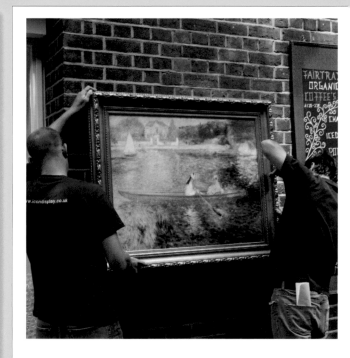

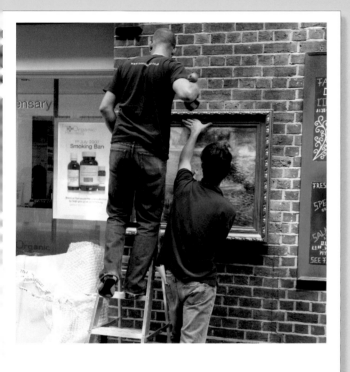

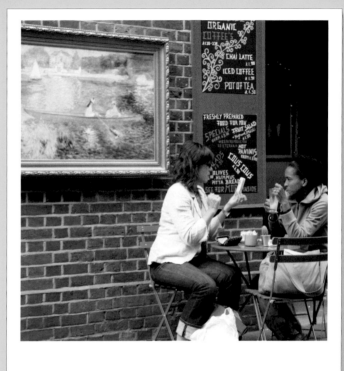

I've always thought that central London … feels like a stage set. The Grand Tour's exquisite paintings in their camp golden frames added a lovely touch of theatricality.

HERVÉ HANNEQUIN, ADVERTISING PROFESSIONAL

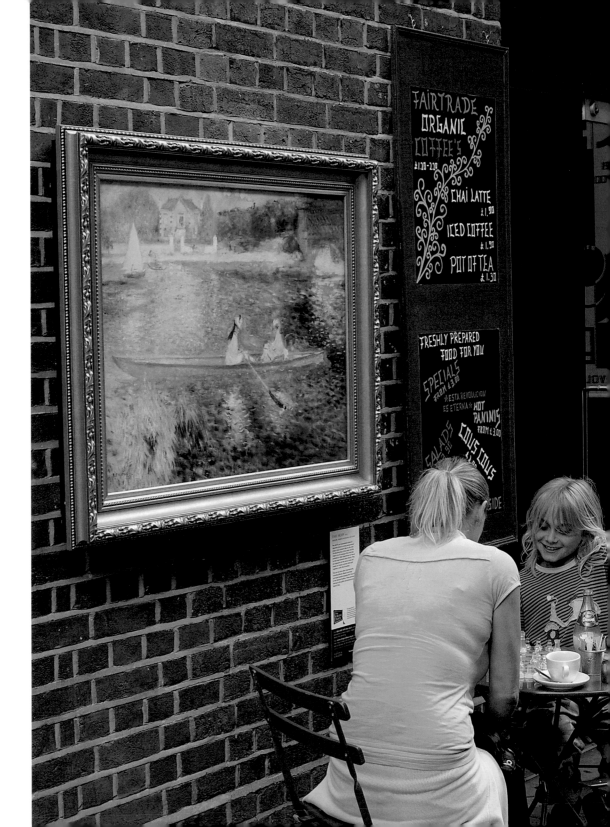

The Skiff, 1875

Renoir (1841–1919)
Photograph: **MATTHEW HYDE**

People came here for a coffee and then went on to the next picture. People liked sitting underneath the painting ever so much. They really did.

SHIRLEY PHILLIPS, CAFÉ ETERNO

Je suis tombé par hasard sur ces reproductions. Magnifique!

JEAN-PHILIPPE WEBER, GALLERY VISITOR

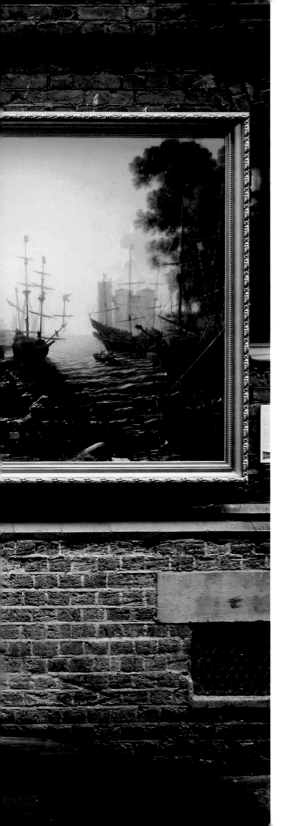

Seaport with the Embarkation of Saint Ursula, 1641

Claude (1604/5?–1682)
Photograph: **CRAIG RICHARDSON**

You don't always have time to go to the galleries, and London is so full of modern stuff that you feel is a little bit derivative, that to have the classics around you every day is just brilliant.

PASSER-BY

The blogosphere has called it a 'challenge
to Banksy' and 'two fingers up to Banksy'.
But in many ways, the National Gallery
has learned a trick or two from Banksy.
Museums in London are free, so this
lesson is not so much about accessibility
but recontextualisation.

ALLYSON SHAW, BLOG

A Banksy-style stencil was spotted tucked
beneath the Gallery's picture.

Philip IV of Spain in Brown and Silver, about 1631–2

Velázquez (1599–1660)

Photographs: **ESTHER SIMPSON** (opposite) | **LUICA MAK** (below)

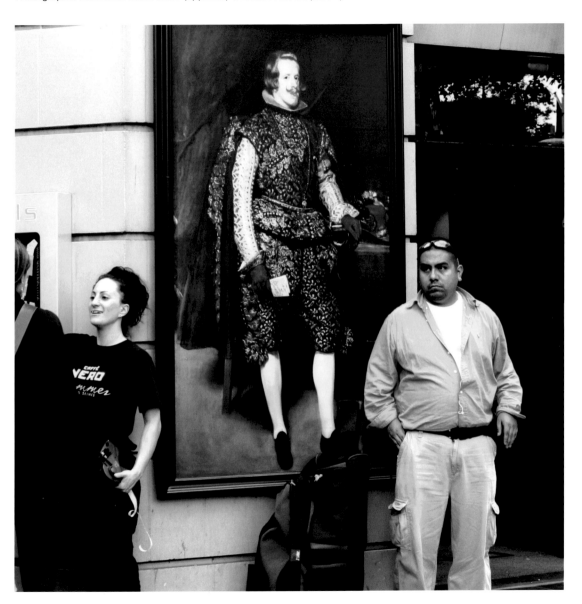

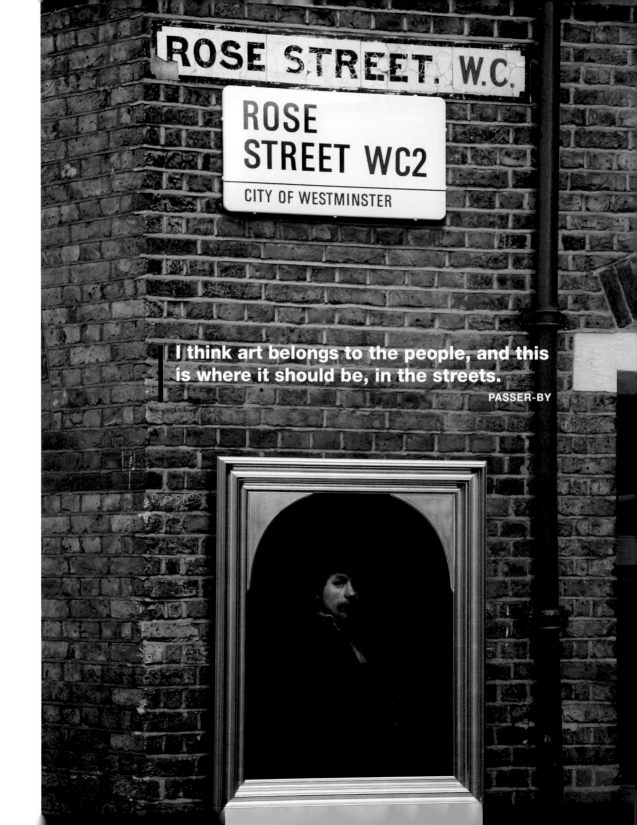

ROSE STREET. W.C.

ROSE
STREET WC2
CITY OF WESTMINSTER

I think art belongs to the people, and this is where it should be, in the streets.

PASSER-BY

Self Portrait at the Age of 34, 1640

Rembrandt (1606–1669)

… the thing about paintings stuck to the outsides of buildings in ordinary streets is that they're just so much more striking than when you encounter them in a stuffy old gallery.

ONLINE ARTICLE, *FRIDAYCITIES*

I think it's a great idea to have Rembrandt's self portrait on a public street in London because we're so used to encountering advertisements and posters, and in a way this portrait was a form of self promotion, of advertisement for Rembrandt.

Betsy Wieseman, Curator, The National Gallery

A local street trader displays his goods in front of the reproduction of Monet's *Water-Lily Pond*, prompting a host of emails to the National Gallery.

■ … it was a great shame today to find that the Monet painting by the Origins store in Covent Garden was COMPLETELY obscured by the display of a street trader selling Banksy knock-offs …

Julia, by email,14 July 2007

■ Why was the Monet mounted on a street seller's site? He told me he has a license to display his pictures on that site … he was pleasant to me but fed up with having to repeat the same story to the many visitors …

Carole, by email, 1 August 2007

■ It drove me mad! I had all these tourists saying, 'Oh! Can I have a look? The Monet's behind there!' One woman actually started crying because she couldn't see it properly. And I'd say, 'look, use your imagination! You can go to the National Gallery.' Then we had another one who called the police … but I've actually got a trader's licence. But at the same time a lot of people felt sorry for me and said 'Oh what a silly place to put it!'

Stand vendor at the site of The Water-Lily Pond, *in interview after the Grand Tour.*

The Water-Lily Pond, 1899

Monet (1840–1926)
Photograph: **NOEL TREACY**

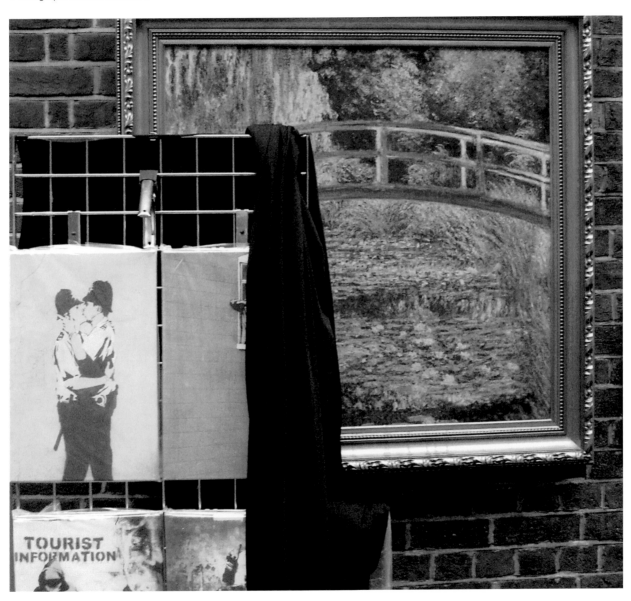

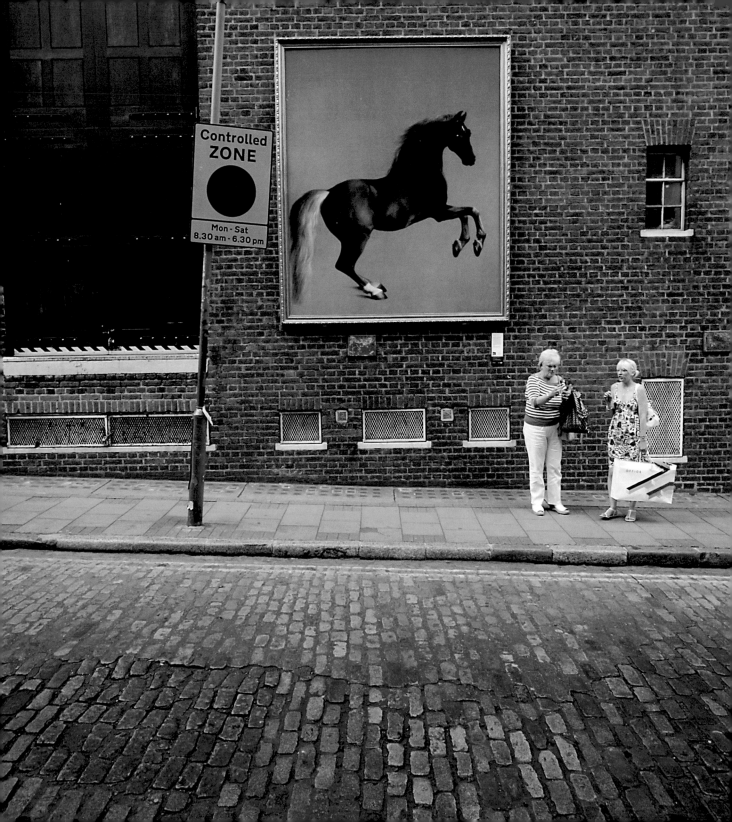

Whistlejacket, about 1762

Stubbs (1724–1806)
Photograph: **BRAD HAYNES**

You can imagine people making arrangements on the phone saying, 'I'll meet you at *Whistlejacket* at 12:30' and getting the reply, 'No, it's more convenient to meet at *Samson and Delilah*'.

ANDREW GRAHAM-DIXON, GRAND TOUR OPENING SPEECH

I think it's a painting that quite literally stops traffic. When it was acquired it was projected on the side of the National Gallery Sainsbury Wing and the police had to intervene because it was causing so many accidents: a wonderful testament to its power for us today.

Jonathan Conlin, historian

It's a very nice idea, and now I learn about the city as well.

LONDON TOURIST

A Young Woman standing at a Virginal, about 1670–2

Vermeer (1632–1675)

Photograph: **HWA YOUNG JUNG**

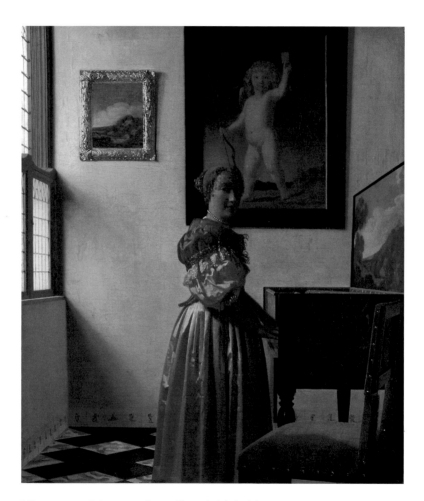

Like many visitors to the gallery, I think this is one of my favourite paintings. It has such a seductive calm about it – I find it so restful to look at it.

Betsy Wieseman, Curator, The National Gallery

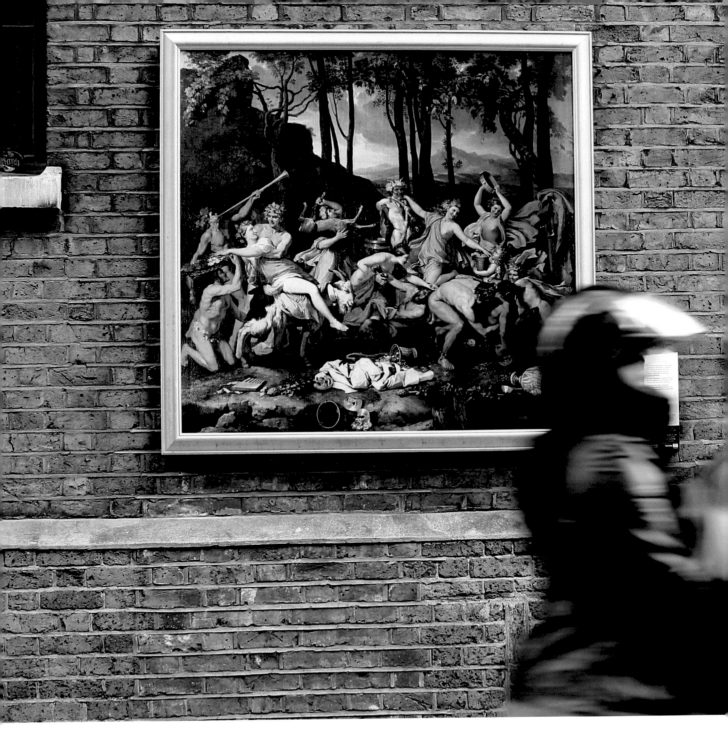

The Triumph of Pan, 1636

Poussin (1594–1665)

Photograph: **LUICA MAK**

Poussin made and placed little statuettes in a stage set to get his composition the way he wanted it.

Aliki Braine, Lecturer, The National Gallery

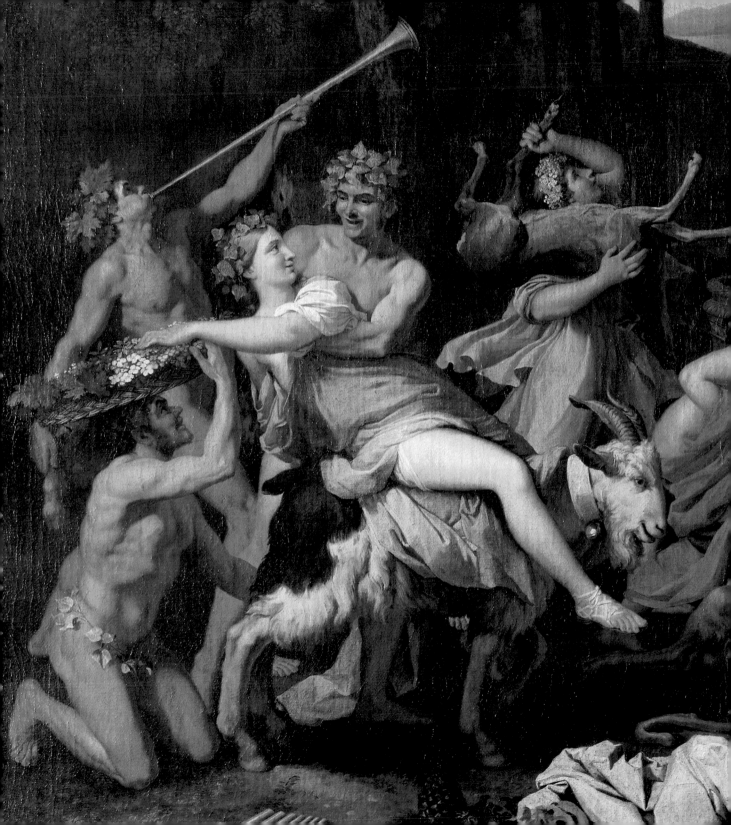

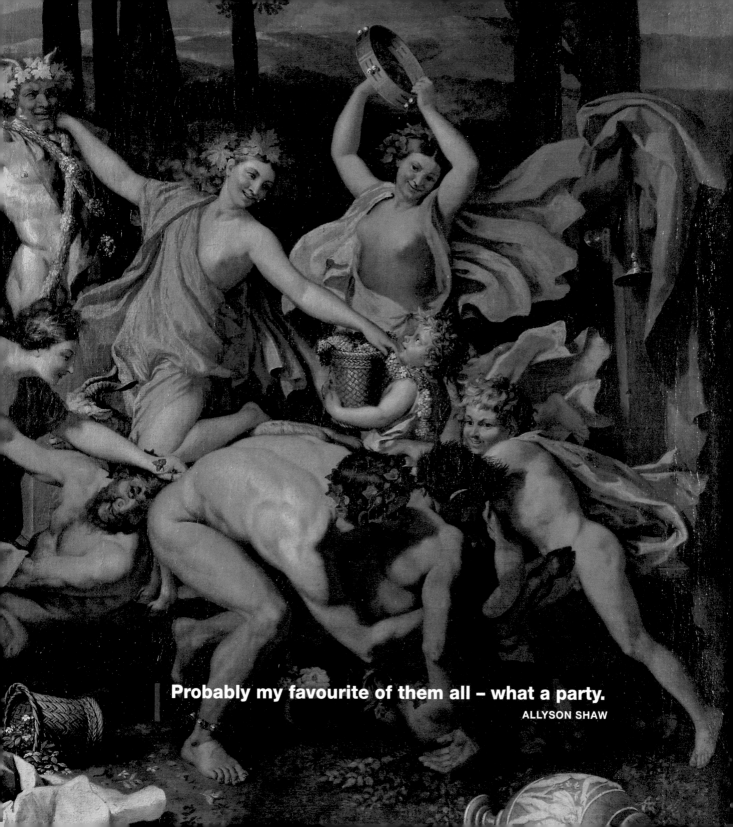

Probably my favourite of them all – what a party.
ALLYSON SHAW

What a splendid summertime treat: strolling through Soho with Caravaggio by your side

BY HOWARD JACOBSON

Independent

11 August 2007

Though we abhor metropolitan self-engrossment in this column, we turn our attention today to an event that has brightened that dusty little corner of humanity we call the West End of London. The National Gallery's decision to hang full-size reproductions of great paintings from its permanent collection on walls all over Soho and Covent Garden is what I'm talking about. And while you could argue that a National Gallery should live up to its name and distribute its largesse to the whole country, better somewhere than nowhere.

When they first went up, one at a time – a Caravaggio here, a Joseph Wright of Derby there – it was like waking to find that the malicious urban fairies who come and go unnoticed, scrawling and fly-posting while we sleep, had been busy again in the night.

Except that this felt the very opposite of vandalism or malice. Not knowing how they'd got there initially I took them to be the charitable offering of some local millionaire eccentric. Then explanatory plaques began to appear alongside the paintings and the hand of the National Gallery and its sponsor Hewlett-Packard was declared.

Clever PR for both – 'See what we've got', says the National Gallery; 'See what we can reproduce', says Hewlett-Packard – but the intention remains benign. A long way from the demented desecration of the graffitist.

I've never got on with graffiti, even when it's higher order graffiti. The thought for the day above my column a few weeks ago was Susan Sontag's famous remark, 'Interpretation is the revenge of the intellect upon art', and that's how I understand the impulse to make graffiti – as interpretative in the sense that it doesn't come about of itself, as art does, but must impose its will, parasitically, on what's already there. It doesn't matter whether that something already there is a train, a doorway, a sculpture, or quite simply the existing fabric of society, the graffitist will exact his critical revenge on it. He cannot leave alone what came before him.

This explains why we always read a sort of alienated envy in graffiti. Whereas the Vermeers and Fragonards which descended as on the wings of angels in the night... Yes, I know the counter argument. Does turning Soho into a museum for showing work long accepted into the canon – turning it into a street version of a National Trust gift shop – do any more for art than giving it over to someone raging at contemporary life with an aerosol can? Might be prettier, but who ever said art had to be pretty?

The National Gallery attempts to tread the line between complacent connoisseurship and discovery by means of a little techno do-it-yourself. There's a Tour Map you can download, showing you where every painting is sited – though you have to be careful not to get trapped for ever in the version that requires a flash plug-in, because then you're into installations that don't install and boxes telling you that there's no default application to open what you would install if only they'd let you install it. Better just to print out the one that doesn't flash or show pedestrians and cyclists moving like Mary Poppins across the West End skyline.

I love running into a Rubens while nipping out to buy a paper, or having a Holbein to look at while hailing a taxi

On top of that there are audio guided perambulations that can be downloaded as zip files which you can drag into the software for your MP3 player. The first of these calls itself the Grand Tour and takes

in the entire offering of 44 paintings. It was marred for me when I tried it, first by the rain, then by the sun, and finally by my discovering that though the paintings are numbered they are not numbered in any intelligible geographical sequence, so that you've dashed there and back 10 times between Putrefaction Alley in Soho and Kitsch Court in Covent Garden and still only got to painting number three.

The second walk is called The Heavy Hitters Tour which doesn't shilly-shally on the margins of greatness but takes you straight to Da Vinci and Van Gogh. And the third, The Lovers Tour, guides you past the more sophisticated sex and tea shops in this part of London via Bronzino's *An Allegory with Venus and Cupid*. If I have one complaint about the latter it is this: it shows, I think, a lack of nerve to suggest rounding this tour off with a bowl of noodles at Wagamama, but not come up with the name of a nearby hotel.

Bronzino's *Allegory with Venus and Cupid* for God's sake! – that's the one where Cupid holds the head of Venus with one knowing boyish hand while with the other (between his index and middle finger to be precise) he rolls her rosy nipple. Small wonder that to the left of Cupid a grey-green figure, variously interpreted as Jealousy and Despair but which I like to think of simply as Deranged Desire, tears his hair and howls. Now tell me a bowl of noodles will do you as a sequel to my description, let alone to the work reproduced in all its grand salaciousness.

In the time it has taken me to write this column so far, four new tours have appeared on the National Gallery's website, so we must assume the idea has taken off.

Good. I approve the project unreservedly. I love running into a Rubens when I'm nipping out to buy the papers. Love having a Holbein to look at when I'm hailing a taxi, rather than a handbill or a road sign. And everyone I talk to feels the same. Even the most difficult to please of London's bloggers report obediently downloading maps, charging their MP3s, getting on their bicycles, and marvelling over the sometimes

By universal consent, the Grand Tour has turned a pig's ear of a summer into a silk purse.

fortuitous, sometimes brilliantly engineered juxtaposition of art, architecture and life.

Snap a hooker hanging around Caravaggio's *Salome receives the Head of Saint John the Baptist* in a puddle of urine and the Devil knows what else outside a Lithuanian whorehouse in Peter Street, or a couple of piss-pots slumped in front of Rembrandt's end-of-the-world *Belshazzar's Feast* on the wall of the theatre where they're showing Les Mis, and you've made a sort of art yourself.

Credit where credit's due: this has turned out to be everybody's idea of a good time. Art, you see. And not just any art, not another fatuous shop-window installation, but painting. By universal consent, the Grand Tour has turned a pig's ear of a summer into a silk purse.

Now let's start seeing the great paintings in our possession on walls all over the country.

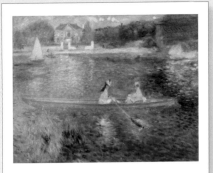

THE SKIFF, 1875

PIERRE-AUGUSTE RENOIR
(1841–1919)

The Skiff is an Impressionist vision of suburban leisure, as two young women enjoy a lazy summer's day on the river.

The shimmering blue of the water and the bright chrome orange of the boat also provided an ideal opportunity for Renoir to test current colour theory. The idea was that being opposites on the colour scale they create an intense and vivid contrast when put together, helping Renoir recreate the effects of bright sunlight to dazzling effect.

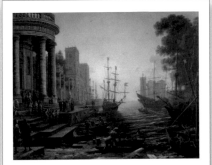

SEAPORT WITH THE EMBARKATION OF SAINT URSULA, 1641

CLAUDE LORRAIN
(1604/5?–1682)

Claude Gellée, called Lorrain after his birthplace, was the first landscape specialist to achieve international fame. His poetic reinventions of a golden age had a profound influence on landscape painting, and landscape gardening, particularly in eighteenth-century England.

The story of Saint Ursula was popular during the Renaissance, but was less common during Claude's time. According to legend, Ursula was a British princess who made a pilgrimage to Rome with 11,000 virgin companions. On their way back they were slaughtered by pagan Huns at Cologne when Ursula refused to marry their chieftain. This picture shows her as she prepares to embark on her fateful voyage.

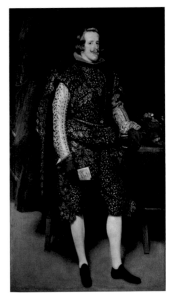

PHILIP IV OF SPAIN IN BROWN AND SILVER, ABOUT 1631–2

DIEGO VELÁZQUEZ (1599–1660)

Velázquez became an official court painter when he was 24 and Philip IV was just 18. The young men were close – when Velázquez left Madrid to study in Italy for two years, Philip refused to be portrayed by anyone else.

This sympathetic royal portrait, painted soon after Velázquez's return, reveals a certain timidity in Philip's eyes, though the pose is confident. The real triumph of the work is the costume, rendered freely in brushed blobs and strokes to create an impression of glinting silver embroidery over rich, lustrous cloth.

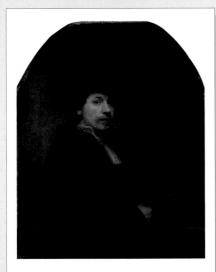

SELF PORTRAIT AT THE AGE OF 34, 1640

REMBRANDT (1606–1669)

One of Rembrandt's favourite subjects was himself. It is reckoned he painted between 50 and 60 self-portraits, more than any other artist of the seventeenth-century.

Here, Rembrandt was at the height of his powers, and he shows himself as a wealthy man and successful painter. He is dressed in an elaborate, sixteenth-century style costume that mimics Titian's *Man with a Quilted Sleeve*, inviting direct comparison with this Italian master.

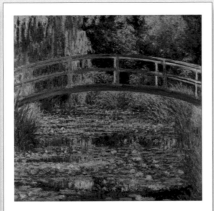

THE WATER-LILY POND, 1899

CLAUDE-OSCAR MONET (1840–1926)

The Impressionists were obsessed with all things Japanese. Once he became rich and famous Monet painstakingly cultivated an Oriental water garden on his estate at Giverny in rural France. The layout of the garden was copied from a print that hung in his dining room.

Monet painted at least 18 different views of the lily pond with the Japanese bridge at various times of day, all from the same perspective. The National Gallery's painting is one of the most tranquil, and has fresh greens and mauves balanced by yellows and reds that evoke an early summer's day.

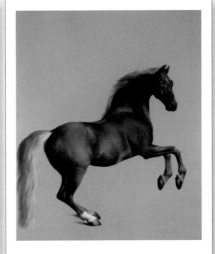

WHISTLEJACKET, ABOUT 1762

GEORGE STUBBS (1724–1806)

Owned by the Marquess of Rockingham, Whistlejacket was one of the most celebrated racehorses of the day. Legend has it that George III was to appear riding the horse in the painting, but Rockingham later changed his mind when they had political differences.

George Stubbs was a stickler for accuracy. He studied anatomy and dissected horses so he could get them absolutely right. It is said that the painting of Whistlejacket was so lifelike that when the horse caught a glimpse of the painting, he reared up in fright and tried to attack the canvas.

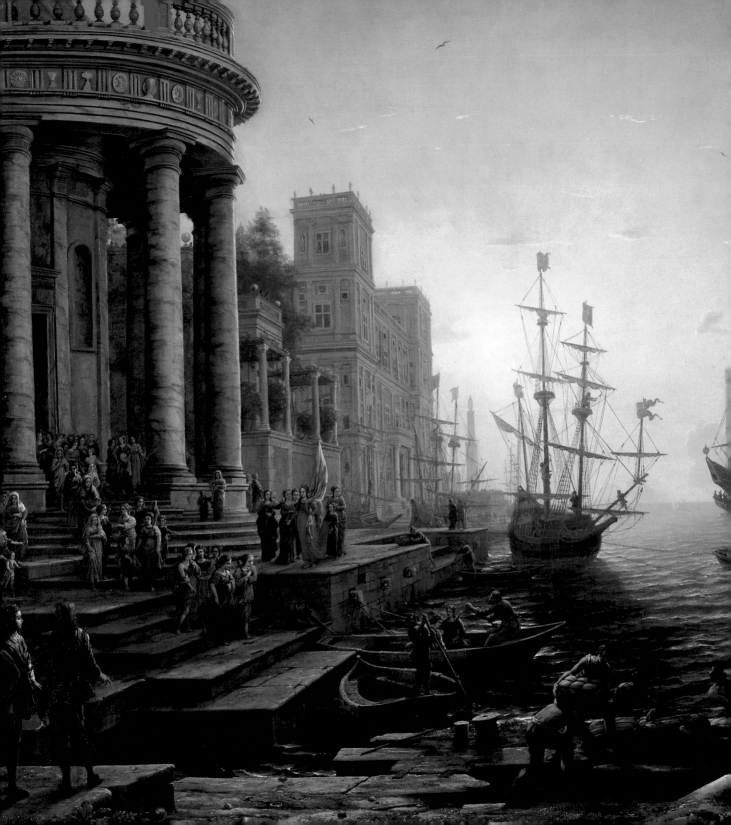

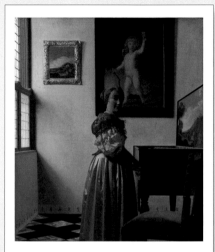

A YOUNG WOMAN STANDING AT A VIRGINAL, ABOUT 1670–2

JOHANNES VERMEER (1632–1675)

Only around 30 paintings by Vermeer are known today. That's because he worked very slowly, ran an inn and an art dealership, and died at just 43.

This serene domestic interior bears all the hallmarks of his paintings. The arrangement is fastidious, a finely balanced geometry containing beautifully worked details that combine to tell a story. The woman, looking expectantly in our direction, plays music reminding her of the man who isn't there, signified by the empty chair. Cupid, in the painting behind her, holds up a single playing card, a symbol of fidelity.

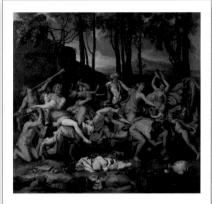

THE TRIUMPH OF PAN, 1636

NICOLAS POUSSIN (1594–1665)

The Triumph of Pan shows a wild, pagan celebration in full swing. It's packed with literary and visual references, demonstrating not only Poussin's mastery of painting, but his deep classical scholarship.

The work belonged to Cardinal Richelieu, Chief Minister to the King and virtual ruler of France, and was housed in an extravagant room dripping with fine art and gilt décor.

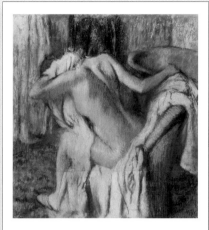

AFTER THE BATH, WOMAN DRYING HERSELF, ABOUT 1890–5

HILAIRE-GERMAIN-EDGAR DEGAS (1834–1917)

Plagued by eye-trouble, in later life Degas was confined to indoor subjects, where he could control the lighting and conditions. He favoured bright pastels, not only because they produced vivid, modern colours, but also because he could see them more easily.

The woman in the painting is going about an intimate and everyday act, unaware of the viewer. Degas seems to have extended his composition while working on it, adding other pieces of paper. He's exploited the flexibility of his pastels to create sumptuous textures and blurred contours suggesting movement.

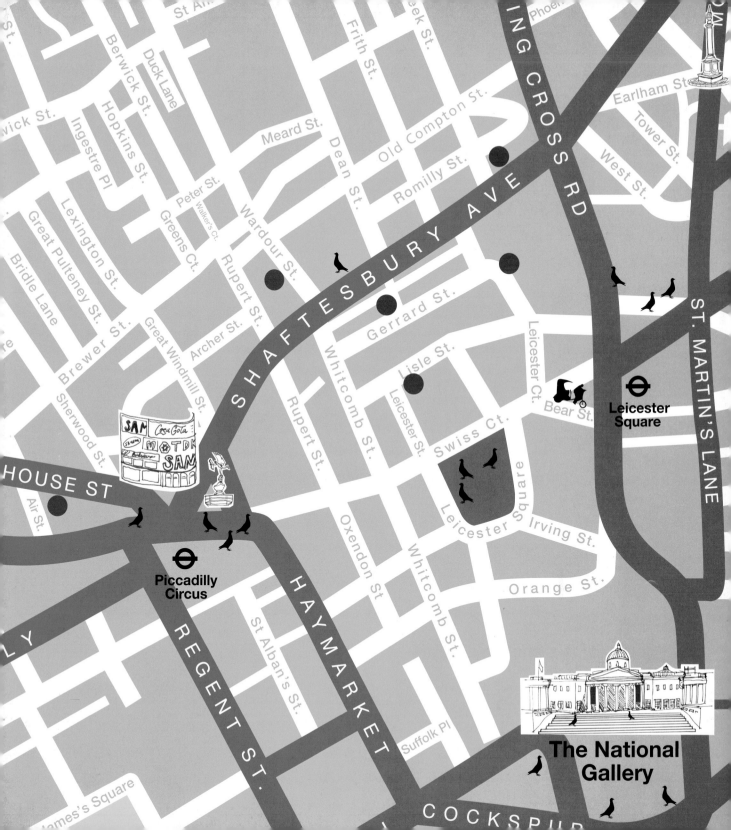

CHINATOWN TO PICCADILLY

ROUSSEAU
REYNOLDS
MICHELANGELO
REMBRANDT
TURNER
EECKHOUT

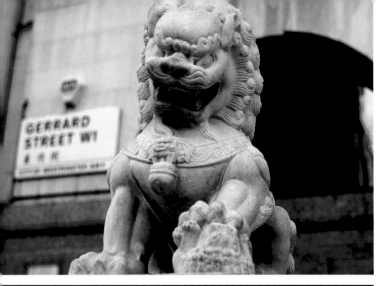

DWARFED BESIDE THE BILLBOARDS of Piccadilly Circus and multiplex cinemas of Leicester Square, Chinatown's tiny cluster of streets offers a short – and, for some, unexpected – detour into another continent.

You could bypass it without knowing it was there. Yet the minute you walk into its confines (namely the square created by Gerrard Street, Lisle Street and Wardour Street), there's no mistaking your whereabouts. The distinctive red and gold lamp-posts, the street signs with Chinese translations and the smell of fried spices hanging in the air – all its characteristic features – combine to create a unique picture.

Window shopping takes on a new meaning here. Wandering past the shop fronts offers a perfect vantage point for watching herbalists weigh out medicines, dim sum chefs lining up their creations, and rows of crispy ducks glistening on skewers.

The numerous Chinese restaurants and supermarkets may only have been established from the 1970s onwards, but they have defined the area in such a way that it's the standard British pub that now looks out of place.

Naturally, the most colourful time to visit is during the Chinese New Year at the end of January or early February, when ornate dragons dance through the streets and paper lanterns fill the air.

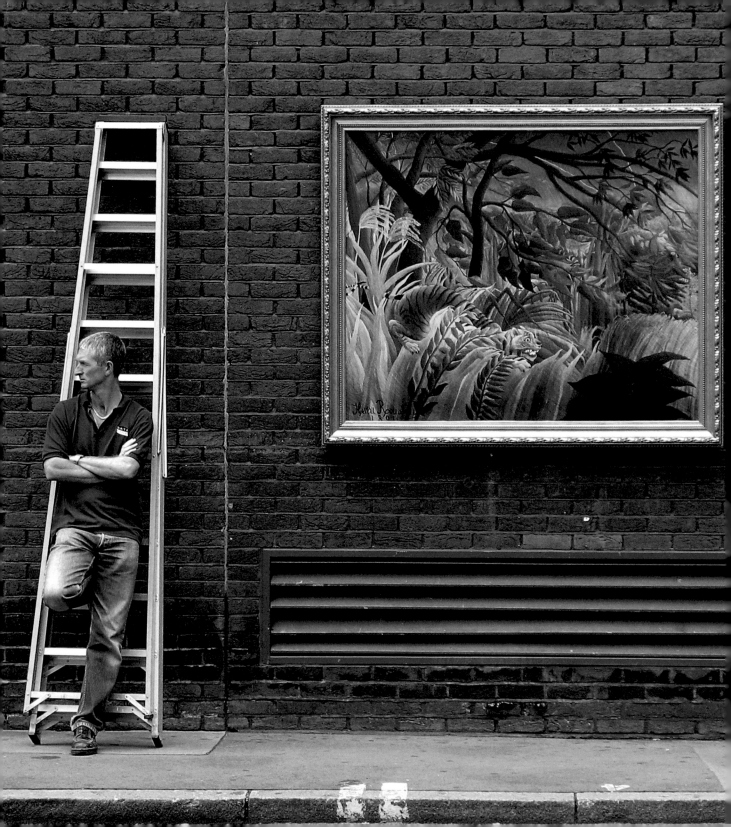

Surprised!, 1891

Rousseau (1844–1910)
Photograph: **ESTHER SIMPSON**

Situated at one end of Gerrard Street, Henri Rousseau's *Surprised!* rather sums up the spirit of the whole venture. Like the tiger in this painting, the works in the Grand Tour pounce out at you as you're going about your business, and like a pack of flamingos rummaging in your bins, it's their skewed context as well as their innate beauty, that makes you gasp.

ONLINE ARTICLE, *FRIDAYCITIES*

Young children immediately understand the intensity of this painting.

Christopher Riopelle, Curator,
The National Gallery

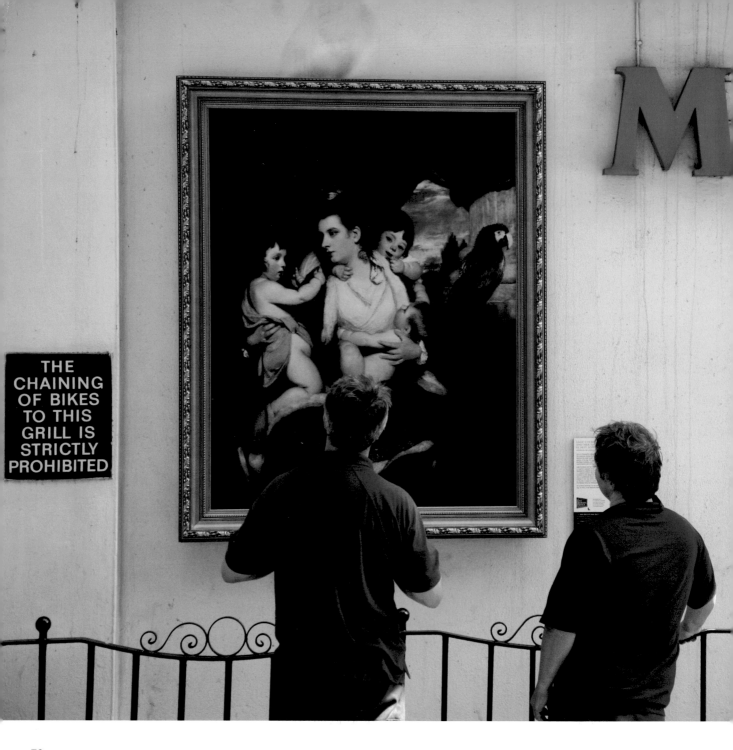

THE
CHAINING
OF BIKES
TO THIS
GRILL IS
STRICTLY
PROHIBITED

Lady Cockburn
and her Three Eldest Sons, 1773

Reynolds (1723–1792)
Photograph: **MATT STUART**

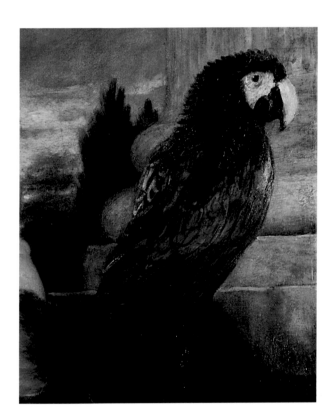

Reynolds had a macaw to entertain his sitters, but his housekeeper hated it because it would flap around and its droppings were everywhere. But I'm sure it would have entertained these children.

James Heard, Education Department,
The National Gallery

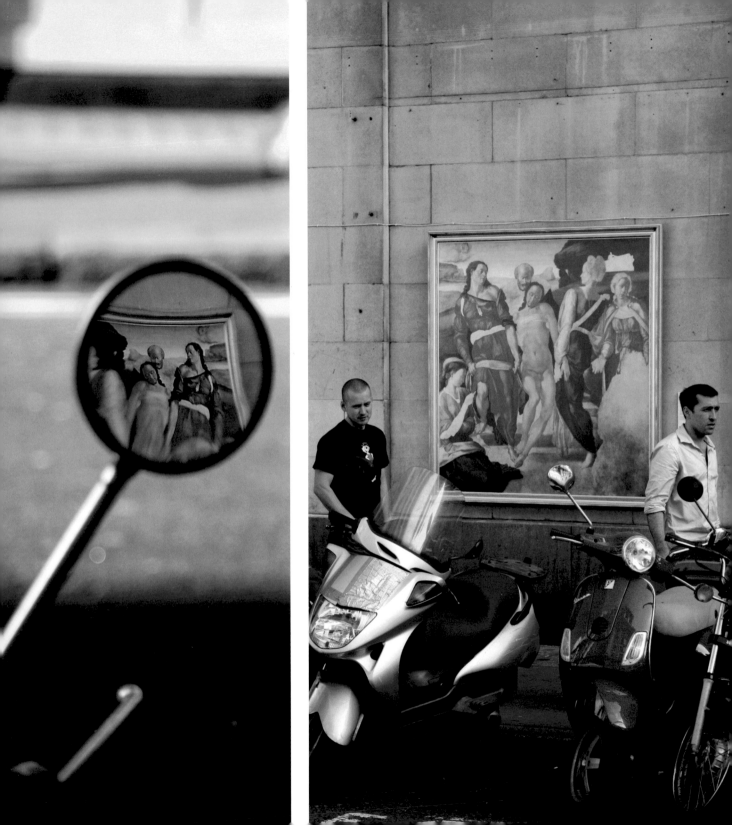

The Entombment, about 1500–1

Michelangelo (1475–1564)
Photographs: **MATT STUART**

The pictures add a bit of something different, sometimes brilliantly juxtaposed with the area they hang in...

TONY LLOYD, BY EMAIL

I've just enjoyed the excellent Piccadilly Circus Lunch Break tour – it was thoroughly enjoyable – much better than a sandwich at my desk.

DARREN BOSTON, GALLERY VISITOR

Although it is sad when a painting's unfinished … you have a sense of the thought process of the artist and that's always very exciting.

Al Johnson, Lecturer, The National Gallery

Has anyone seen this picture?

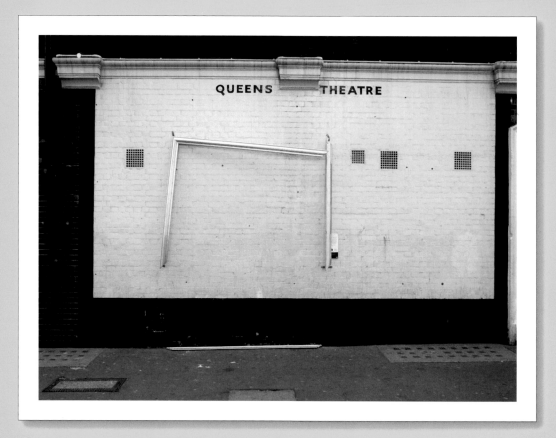

During the Grand Tour four pictures went 'missing', including the reproduction of *Belshazzar's Feast* hung on the wall of Queens Theatre. CCTV captured the moment of its disappearance (overleaf).

The Grand Tour organisers do not expect to get the missing picture back but would love to know where it got to. So if you've seen it, or if you have it, let us know!

Belshazzar's Feast, 1636–8

Rembrandt (1606–1669)

Photograph: **BRAD HAYNES** (opposite)

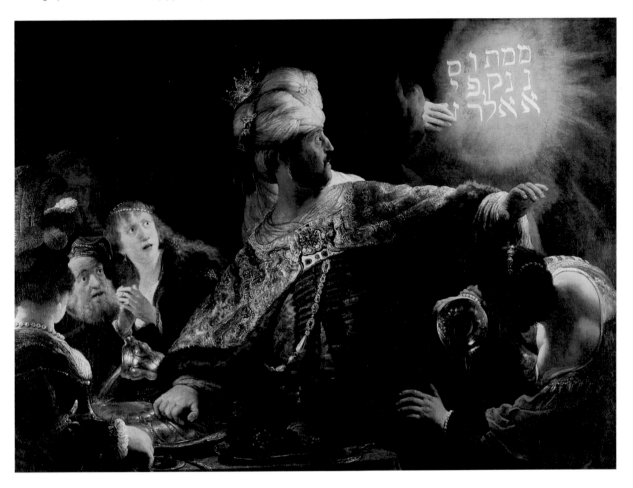

The sounds that come to me when I look at this scene are absolute silence … you can sense that some of the vessels have just clattered to the table as God's message appears written on the wall.

Betsy Wieseman, Curator, The National Gallery

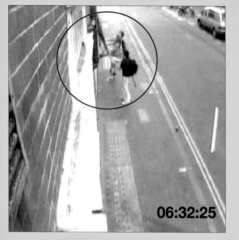

06:32:25

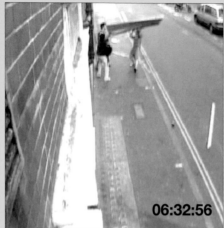

06:32:56

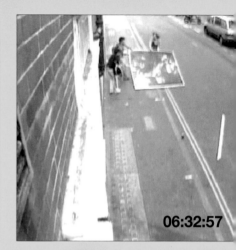

06:32:57

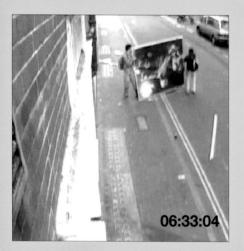

06:33:04

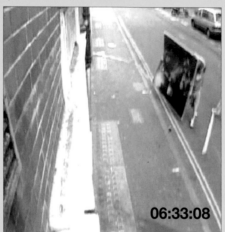

06:33:08

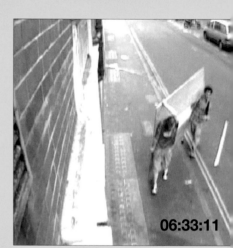

06:33:11

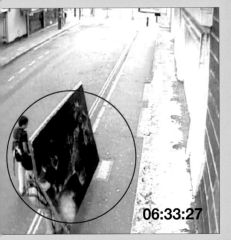

06:33:27

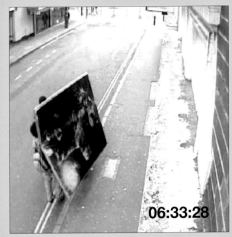

06:33:28

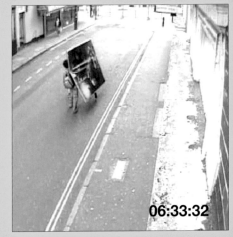

06:33:32

 CAMERA THREE

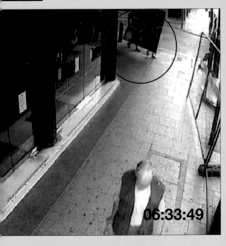

06:33:49

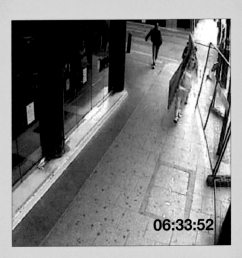

06:33:52

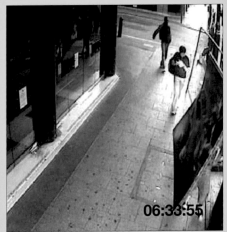

06:33:55

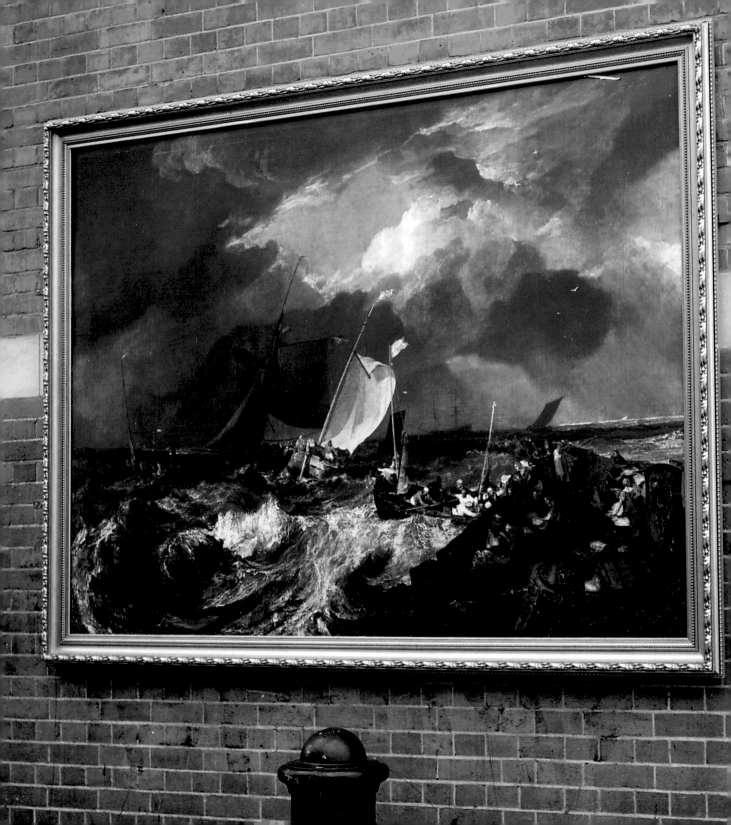

Calais Pier, 1803

Turner (1775–1851)
Photograph: **HWA YOUNG JUNG**

I remember the painting; there was a hole in the clouds and the sun … was coming through. And if it was raining outside then the hole [in the painting] looked like part of the storm, but if it was a bit sunny then it looked like the sun … The painting changed with the weather.

ANTONIO, EMPLOYEE AT CARRIAGE AND HORSES PUB,
SITE OF *CALAIS PIER*

87

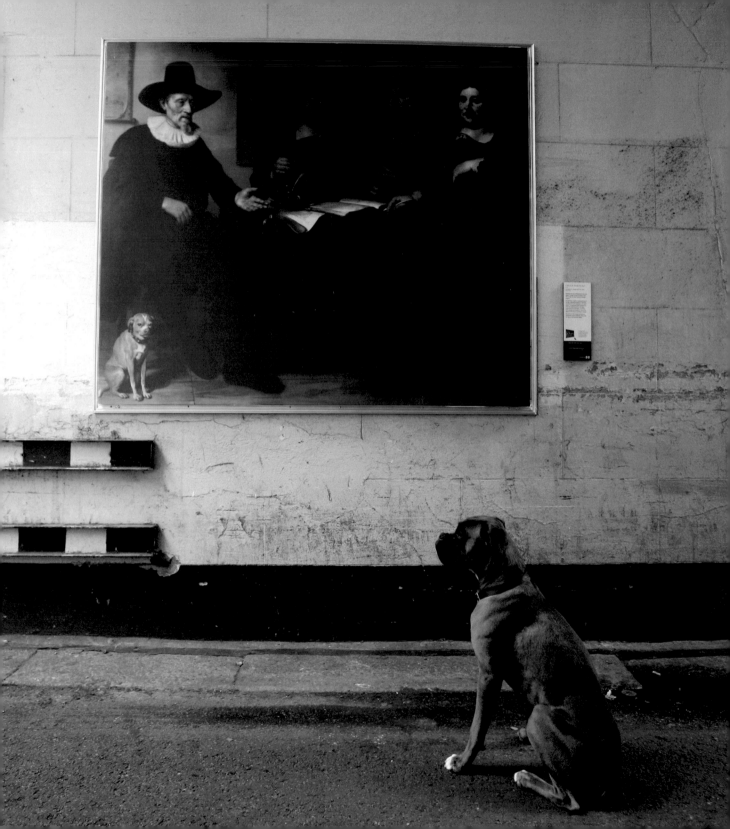

Group Portrait, 1657

Eeckhout (1621–1674)
Photograph: **DAVID LEVENE**

I'd like to see the idea repeated at some point in the future, even further afield … I'd like to see Gainsboroughs in industrial estates in Dagenham, Canaletto in a drab row of shops in Potters Bar, Lotto's *Lucretia* in a multiplex cinema in Wimbledon.

ROB SMITH, BY EMAIL

My favourite part of the painting has to be the dog in the lower left-hand corner. And my favourite part of the dog is that wonderful, pink nose. You just know it's cool and moist; you just want to touch it!

Betsy Wieseman, Curator, The National Gallery

The National Gallery's Grand Tour is its best show ever

BY MAEV KENNEDY
Guardian Unlimited
13 June 2007

'Fabulous quality!' the man said to two blue-suited colleagues, running an admiring fingertip down Seurat's *Bathers at Asnières*.

I fear he meant the truly startling quality of the reproductions by Hewlett-Packard, but he could have been talking about the whole project, 44 life-size copies of masterpieces from the National Gallery, hung at head height, handsomely framed and wittily captioned, on carefully chosen walls all over Soho and Seven Dials.

The three suits were scuttling, clutching briefcases and portfolios, through Kingly Street, an unlovely street in Soho which is effectively one long loading bay for Regent and Carnaby streets, when they were literally stopped in their tracks by art.

You could see the same effect all over the surrounding streets: on Glasshouse Street an elderly Chinese woman blessed herself as she passed Michaelangelo's wrenching *Entombment*.

Not all the paintings can hack it. *The Fighting Temeraire* has sunk, somehow fatally holed by a long dull building on Golden Square – unlike Titian's *Bacchus and Ariadne* in St Anne's Court, where the narrow alley forces you into an almost uncomfortably close embrace with all that naked flesh.

On Glasshouse Street an elderly Chinese woman blessed herself as she passed Michaelangelo's wrenching *Entombment*.

Most work astoundingly well. The most composed woman in the National Gallery, little *Christina of Denmark* by Holbein, so deceptively demure in her plain dark gown, so beautiful without so much as a tendril of hair showing under her dark cap, the sexy little smile that convinced Henry VIII she'd make an excellent successor to Jane Seymour and the broad clever forehead that led her to turn him down flat, stills the chatter and clatter of Broadwick Street. Even if they kept going, people slowed and smiled at her.

Around the corner Rubens's Samson, sprawled fatally drunk on sex across Delilah's lap, has to compete with a bit of concrete brutalism, and a huge pop art sculpture of a giant electrical plug and socket on the same wall in Ganton Street – and slays them: a postman stopped, stared, and searched through his uniform pockets for his mobile to snap them.

The captions are sharp, informative and unpatronising: one of the sexiest paintings in the entire collection, Botticelli's ravishing *Venus and Mars*, the goddess still cool as a cucumber, Mars sunk in sleep, his mouth just ajar suggesting that he's probably snoring, hung between Sweaty Betty and a nail bar in Kingly Court, is described as 'jam packed with sexual innuendo'.

Every caption reminds the viewer that there are many more not just cheap, but free, thrills jam packed into the National Gallery. People who already visit our great museums tend to assume everyone knows they're free, but that is not true: only last week I spoke to a woman who said wistfully she'd not been in the British Museum since a school visit as a child, and she supposed it's terribly dear now.

A few paintings in streets with less passing traffic – like the appalling encounters with death which flank the end of pretty Meard Street, mortality seeping from Van Gogh's *Cypresses* into his golden wheat field on one side, opposite Joseph Wright of Derby's savage scene of the weeping children forced for their own good to watch the bird's despairing flutters in the bell jar from which the last gasp of air is being sucked – were alone.

But most had at least one person poring over every detail, and many had clumps

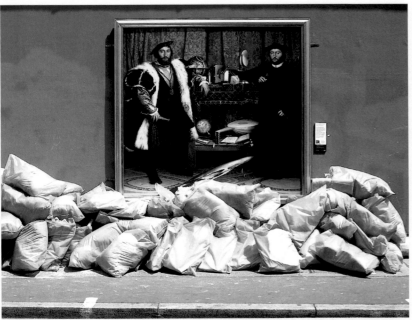

Photograph: MICHAEL WAILES

My opinion – in answer to the young man who almost fell off his bicycle when he met *The Ambassadors* in Berwick Street, blurting out 'what the ** is that?' – is it's the best National Gallery exhibition I've ever seen.**

of people blocking the pavement talking about art, as startling a sight as I've ever seen in London.

Yesterday I managed 21 paintings in just over two hours including two coffee breaks, just under half the total: I never managed to find the Le Nain which should be somewhere around the Shakespeare pub on Carnaby Street, but I'm determined to go back to see how Bronzino's outrageous *Venus and Cupid* is getting on in Greek Street.

I never once managed to get through on the special phone line (0844 800 4172) listed by each picture, so I have no idea what the gallery's expert opinions might be. But my opinion – in answer to the young man who almost fell off his bicycle when he met *The Ambassadors* in Berwick Street, blurting out 'what the fuck is that?' – is it's the best National Gallery exhibition I've ever seen.

SURPRISED!, 1891

HENRI ROUSSEAU (1844–1910)

Rousseau discovered art in his forties, after previous careers as a regimental bandsman and toll collector. Though he claimed his stylised, highly patterned jungle paintings were informed by first-hand experience with the French army in Mexico, it is now thought he never travelled there, and was instead inspired by prints, visits to the local botanical gardens and humble houseplants.

When he first exhibited his large, dreamlike canvas, *Surprised!*, the title may have been a reference to a sudden storm breaking, but later Rousseau said it related to explorers outside the picture frame about to be pounced on by a tiger.

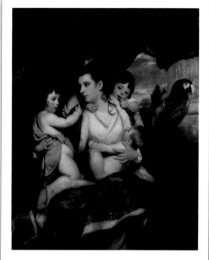

LADY COCKBURN AND HER THREE ELDEST SONS, 1773

SIR JOSHUA REYNOLDS (1723–1792)

Son of a Devonshire village school master, the tenacious Joshua Reynolds rose to become the most sought-after portrait painter of his age. He was a founder of the Royal Academy, and friend to the most eminent men of letters in England.

Lady Cockburn and her Three Eldest Sons is a perfect example of the way he idealised his subjects by portraying them in a classical context. Reynolds paints Lady Cockburn as the allegorical figure Charity, who is traditionally shown with three children in this way. James, the older boy on the left, is based on Cupid, as seen in *The Rokeby Venus* by Velázquez.

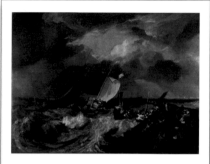

CALAIS PIER, 1803

JOSEPH MALLORD WILLIAM TURNER (1775–1851)

Based on Turner's very first trip abroad the previous year, the dramatic *Calais Pier* is born from frightening reality. On a preliminary sketch, Turner noted the seas had been so rough he was 'nearly swampt'.

The raging, turbulent movement of the waves, the looming clouds and sun breaking through on to the ship's sails – almost like a spotlight – are all deftly handled. Yet when he first exhibited the picture at the Royal Academy in 1803, he was criticised for not having finished the foreground.

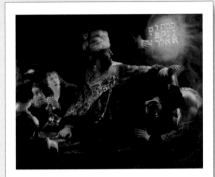

BELSHAZZAR'S FEAST, 1636–8

REMBRANDT (1606–1669)

Rembrandt wanted to be remembered as a religious history painter. But in the strict Dutch Republic, lavish adornment of churches was off the agenda.

Instead, Rembrandt recreated grand Biblical scenes for private clients. This one is the story of the King of Babylon. Framed and lit like a movie still, Rembrandt carefully captures the dread and horror of the guests when the divine inscription appears on the wall foretelling the ruin of Belshazzar's kingdom.

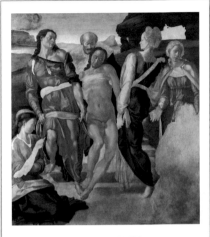

THE ENTOMBMENT, ABOUT 1500–1

MICHELANGELO (1475–1564)

This strikingly early work by Michelangelo was intended as an altarpiece. The perspective is arranged so that to viewers looking up, it would have appeared as if Christ's body is being lowered onto the altar below.

The empty outline on the right is reserved for the Virgin Mary, in mourning for her son. Michelangelo may have been waiting for rare and costly ultramarine pigment for her traditional blue cloak, when he was called away to return to Florence leaving the painting unfinished.

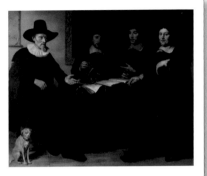

GROUP PORTRAIT, 1657

GERBRAND VAN DEN EECKHOUT (1621–1674)

Eeckhout was one of Rembrandt's favourite pupils. But although he was able to work in his master's style, he wasn't quite so daringly original.

The painting is typical of group portraits of the age, depicting prosperous, behatted businessmen in the equivalent of a team photo. This particular guild included the men who made barrels for the wine imported into Amsterdam, and others who sampled and bottled it. One of the gents in the picture is Eeckhout's brother.

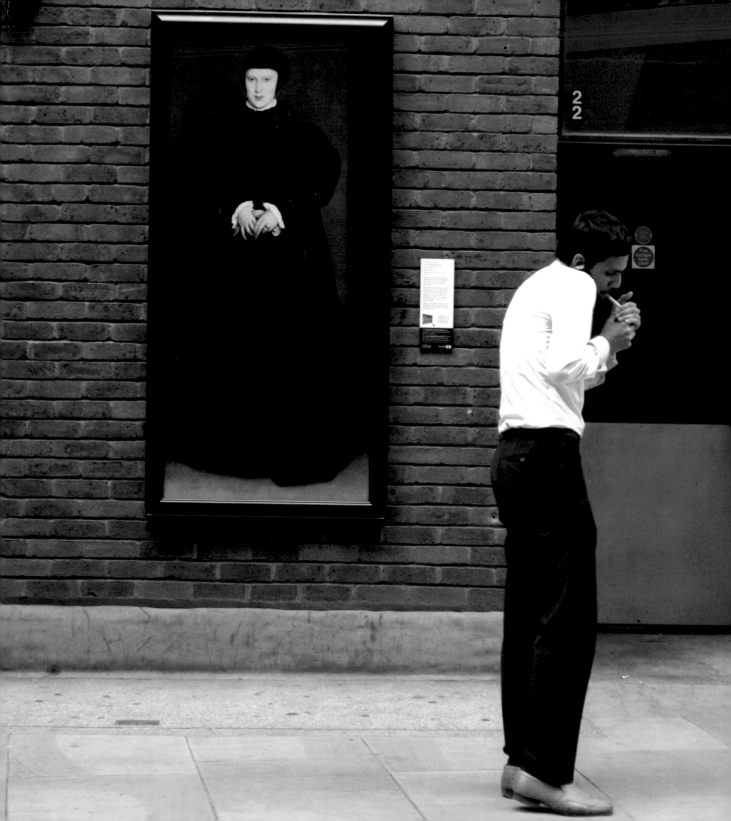

The National Gallery thanks Hewlett-Packard for their generous sponsorship of this book.

First published in Great Britain in 2008 by
National Gallery Company Limited
St Vincent House
30 Orange Street
London WC2H 7HH
www.nationalgallery.co.uk

ISBN 978 1 85709 428 2
525529

British Library Cataloguing-in-Publication Data
A catalogue record is available from the
British Library

Publisher Louise Rice
Project Editor Davida Saunders
Designer Bianca Ng
Picture Researcher Suzanne Bosman
Production Jane Hyne and Penny Le Tissier
Printed and bound in Hong Kong by
Printing Express Ltd

Photographs by The Partners throughout, unless otherwise indicated.

Front cover: Reproduction of *Surprised!*, 1891, by Rousseau, on Gerrard Street. Photograph: Esther Simpson.
Page 2: Reproduction of *After the Bath, Woman Drying Herself,* about 1890–5, by Degas, on Shorts Gardens.
Page 4: Reproduction of *Madame de Pompadour at her Tambour Frame*, 1763–4, by Drouais, on Glasshouse Street.

Opposite: Reproduction of *Christina of Denmark, Duchess of Milan*, 1583, by Holbein, on Broadwick Street.

The Grand Tour idea and execution: **THE PARTNERS**

Interactive and web: Digit

Exhibition acknowledgements
The Partners; Digit; Electronic Print Services (EPS); Antenna Audio; Nielsen Bainbridge; Simon Robinson & Son; Crome Gallery; Icon Display; everyone who allowed the National Gallery to hang a painting on their wall.

Photographic credits
© The National Gallery, London: 13R, 16, 20–1, 23, 27, 30, 33, 56–7, 61, 64–5, 70, 79, 83. © The Partners: 2, 4, 14, 17, 31, 44L & R, 45L, 52. © Matt Stuart: 10, 12L & R, 13L, 18, 22, 45R, 78, 80L & R.
© Suzanne Bosman: 8, 42, 74. © Brad Haynes: 58, 82.
© Matthew Hyde: 24, 46. © Hwa Young Jung: 60, 87, 94. © David Levene 2007: 88. © Luica Mak: 51, 62.
© Craig Richardson: 48. © Esther Simpson: front cover, 26, 28, 50, 76. © Noel Treacy: 32, 55.
© Michael Wailes: 91.

Text credits
© Andrew Graham-Dixon: 5. © Victoria Baker: 9, 43, 75. © Guardian News & Media Ltd. 2007: 25, 34–5, 90–1. © Seventh Art Productions: 27, *DVD copies of* Tim Marlow's Grand Tour *are available to purchase from www.seventh-art.com.* © Howard Jacobson, first published in *The Independent* 11 August 2007: 66–7. © Allyson Shaw, feralstrumpet.wordpress.com: 15, 18, 50. © london.fridaycities.com: 53, 77.

Finally, it is the participation of the people of London, some of whom appear in these pages, that has made this event such a success. We would like to thank them all.

MORE PAINTINGS ON THE GRAND TOUR

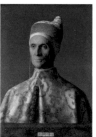
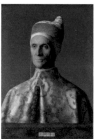

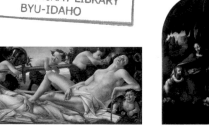

The Arnolfini Portrait, 1434
Jan van Eyck ■

Saint Michael Triumphs over the Devil, 1468
Bartolomé Bermejo ■

The Doge Leonardo Loredan, 1501–4
Giovanni Bellini ■

Venus and Mars, about 1485
Sandro Botticelli ■

The Virgin of the Rocks, about 1491–1508
Leonardo da Vinci ■

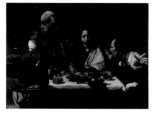

The Four Elements: Earth, 1569
Joachim Beuckelaer ■

The Supper at Emmaus, 1601
Michelangelo Merisi da Caravaggio ■

Cavalry making a Sortie from a Fort on a Hill, 1646
Philips Wouwermans ■

Three Men and a Boy, about 1647–8
The Le Nain Brothers ■

An Extensive Landscape with a Road by a River, 1655
Philips Koninck ■

Psyche showing her Sisters her Gifts from Cupid, 1753
Jean-Honoré Fragonard ■

The Hay Wain, 1821
John Constable ■

Madame Moitessier, 1856
Jean-Auguste-Dominique Ingres ■

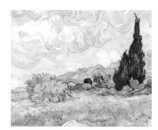

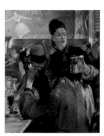

The Fighting Temeraire, 1839
Joseph Mallord William Turner ■

Bathers at La Grenouillère, 1869
Claude-Oscar Monet ■

A Wheatfield, with Cypresses, 1889
Vincent van Gogh ■

Corner of a Café-Concert, 1878–80
Edouard Manet ■